The Technique of Fine Art
LITHOGRAPHY

Michael Knigin and Murray Zimiles

REVISED EDITION

VNR VAN NOSTRAND REINHOLD COMPANY
NEW YORK CINCINNATI TORONTO LONDON MELBOURNE

To Marion, Fred, Jan, and Boris

ACKNOWLEDGMENTS

We gratefully acknowledge Donna Stein of the Department of Prints and Drawings, The Museum of Modern Art, New York, for her invaluable help in editing our manuscript.

We are grateful, also, for the help of Donald H. Karshan, author, collector, critic, and President of the Museum of Graphic Art, New York; Andrew Stasik, Director, Pratt Graphics Center; Clifford Smith, Educational Director, Tamarind Lithographic Workshop; Ernest DeSoto, Director, Collector's Press; Gordon Kluge; and Anna Wong.

Our thanks go to Jean Koefoed, Publisher, and Nancy Newman, Senior Editor, Van Nostrand Reinhold Company.

We thank Jeffrey Loubet, our photographer, and Patrick Kennedy, our illustrator, for their contributions.

And, finally, we acknowledge the following companies for their help with technical information: Andrews/Nelson/Whitehead and Harold Pitman Company.

Copyright © 1977 by Litton Educational Publishing, Inc.
Library of Congress Catalog Card Number 76-54289
ISBN 0-442-24479-7

Printed in the United States of America.
Line drawings by Patrick S. Kennedy.

Published in 1977 by Van Nostrand Reinhold Company
A division of Litton Educational Publishing, Inc.
450 West 33rd Street, New York, NY 10001, U.S.A.

Van Nostrand Reinhold Limited
1410 Birchmount Road
Scarborough, Ontario M1P 2E7, Canada

Van Nostrand Reinhold Australia Pty. Limited
17 Queen Street
Mitcham, Victoria 3132, Australia

Van Nostrand Reinhold Company Limited
Molly Millars Lane,
Wokingham, Berkshire, England

16 15 14 13 12 11 10 9 8 7 6 5 4 3 2

Library of Congress Cataloging in Publication Data

Knigin, Michael.
 The technique of fine art lithography, revised edition.

 Includes index.
 1. Lithography—Technique. I. Zimiles, Murray, joint author. II. Title.
 NE2425.K57 1977 763 76-54289
 ISBN 0-442-24479-7

PREFACE

The idea of writing *The Technique of Fine Art Lithography* came when the authors, who are both artists and teachers, realized that there was no single volume available that presented lithography in a clear and precise fashion. The intention of this book, therefore, is to simplify the complexities of lithographic chemistry, printing, and technique. Although the book is aimed at the student of fine art lithography, it is written so that the average inexperienced layman can easily understand its contents.

We have attempted to organize the various aspects of our subject logically. Our approach is direct and methodical, like a cookbook. Thus, we begin with equipment and proceed to the lithographic stone, the materials for drawing and erasing, preparation for printing, and the printing process itself. Zinc and aluminum plate lithography is treated similarly. Also explained in detail are color lithography, the use of transfer paper, the types of paper and inks available to the lithographer, special effects, and photolithography. We have included a comprehensive section on printing problems and how to correct them, as well as a glossary of chemicals, a general glossary, and a list of suppliers. We have taken advantage of the many products available from the lithographic industry, selecting the specific brands through a tedious process of experimentation. Yet, wherever possible, we have given the artist-printer the choice of fabricating his own solutions.

Lithography is a popular technique today. It lends itself to the creation of almost any type of image, and its immediacy allows the artist to see the results of his labor instantaneously: the drawing is the image. Few if any of the books that deal with lithography discuss contemporary techniques. In recent years, because of experimentation done at workshops such as Chiron Press, Hollander Workshop, Collector's Press, Universal Limited Art Editions, Gemini G.E.L., Tamarind Lithographic Workshop, and Pratt Graphics Center, new techniques have been developed and old ones illuminated. Through a careful selection of reproductions, we hope not only to reveal the scope of lithography as practiced today, but to show in detail how fine prints are made, thus enabling other artists to benefit from the techniques employed.

All of the information in this book has been gathered together to shed new light on a difficult subject, and to encourage all who are interested to partake in one of the most exciting fine art graphic processes available to the contemporary artist.

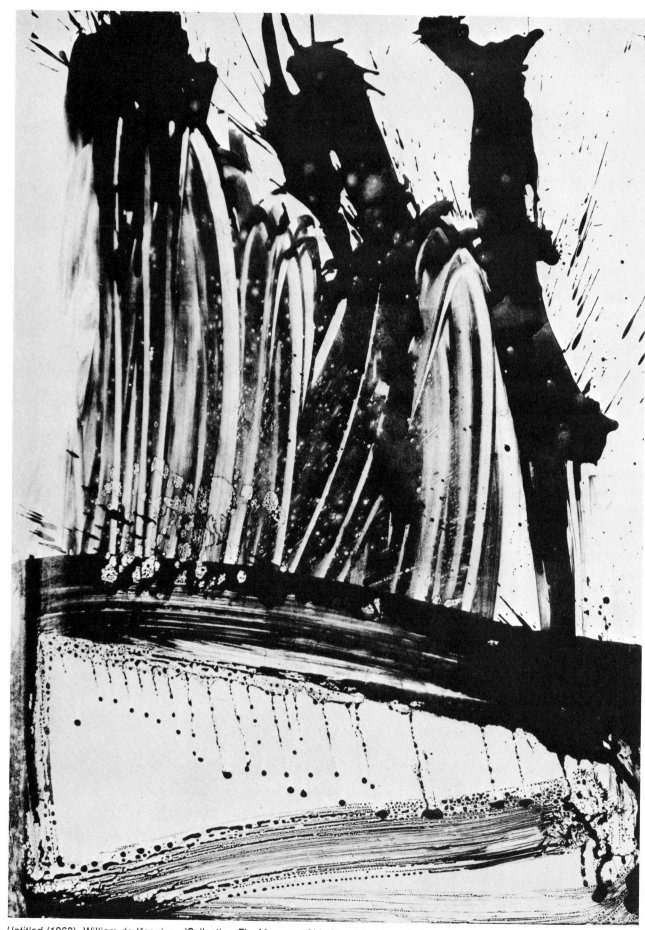

Untitled (1960), William de Kooning. (Collection, The Museum of Modern Art, New York. Gift of Mrs. Bliss Parkinson)

FOREWORD

I am pleased that finally there is a comprehensive practical text devoted to the technique of lithography for the artist-printmaker.

Today most colleges and universities provide instruction in stone and plate lithographic printing using the newest equipment, materials, and presses evolving from the contemporary investments of energy and research in science and technology.

Increasingly, during the last decade, American printmakers attracted by these facilities and the patronage of the university to research and creativity have brought printmaking activity to unprecedented levels of technical proficiency, sophistication, and popularity.

With highly specialized insights gathered from their training and personal experiments carried out in the professional print workshops of the Tamarind Lithographic Workshop in California and the Pratt Graphics Center in New York City, Michael Knigin and Murray Zimiles are representative of the best in the new generation of artist-printmaker-teachers.

Responsive to the needs of their students, fully cognizant of the nature of the private and university print-workshop, and last, but by no means least, recognizing the lack of and need for an appropriate class and studio text-manual, these two gifted young artists have prepared the book which many of us have wanted to be able to recommend for years.

The art of lithography is approached as a medium for creative expression as serious and professional as its sister arts, painting and sculpture. This book, geared to the instructional process, sets about to accomplish what can be viewed as a three-phase goal: (1) to develop an aesthetic sensitivity to and awareness of the medium; (2) to develop a knowledge of process, skills, and materials; and (3) to aid in the formation of critical levels for the evaluation of the total learning experience.

Written as a group of chapters arranged to follow the practice of the medium, the book is a vital instructional tool. The student can now deal with countless potentially difficult situations, independent of the instructor for the first time. The material is presented in specific, well-organized outlines that can be used in group or individual teaching situations.

The Technique of Fine Art Lithography is a major addition to the literature on creative lithography and the art of printmaking relevant to our times, our students, and our artists.

Andrew Stasik
Director
Pratt Graphics Center

Aloys Senefelder
1771-1834

To all to whom these presents shall come, John Aloysius Senefelder, of Gould Square, in the Parish of Saint Olave, Hart Street in The City of London, Gentlemen, sends greeting. Whereas, by His Majesty's Letters Patent under The Great Seal of the United Kingdom of Great Britain and Ireland, bearing date at Westminster, the Twentieth day of June last, reciting that the said John Aloysius Senefelder, had, by his Petition, humbly represented unto his Majesty, that he had, after much trouble, labor, and expense, found out and invented a new method and process of performing the various branches of the art of printing on paper, linen, cotton, woolen, and other articles; that he is the first and true Inventor thereof, and that the same had never been made or used by any other person or persons, to the best of his knowledge and belief; the Petitioner therefor most humbly prayed that His Majesty would be graciously pleased to grant unto him, his executors, administrators, and assigns, His Royal Letters Patent . . . and His Majesty being willing to give encouragement to all arts and inventions which might be for the public good, was graciously pleased to condescend to the Petitioner's request . . . etc.

July 18, 1801

CONTENTS

Introduction

"A novelty to be regarded with extraordinary interest are the first two numbers of 'Specimens of Polyautography,' an invention of Aloys Senefelder, a German by birth, who holds a patent through Mr. André. This German invention is of enormous importance for the arts."—*Englische Miscellen,* October, 1803.

If freedom is essential to the creation of art, then lithography presents boundless opportunities for artistic expression. The process of hand lithography, from which original lithographs are made, is by far the most frequently used graphic medium in the world today. And no wonder, since it offers the artist the widest range of linear, tonal, and chromatic effects by the most spontaneous and direct creative route.

The cutting of wood and stencils and the engraving and acid-biting sequences of relief and intaglio printmaking often create significant time gaps and physical barriers between the creative act and the certain knowledge of the

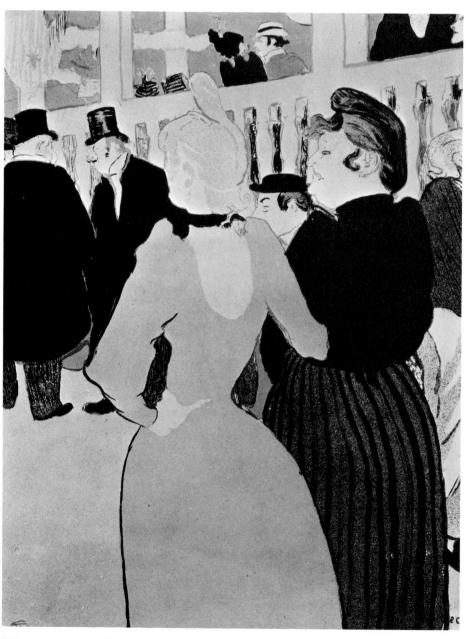

At the Moulin Rouge: La Goulue and Her Sister (1892), Henri de Toulouse-Lautrec. (Collection, The Museum of Modern Art, New York. Gift of Abby Aldrich Rockefeller)

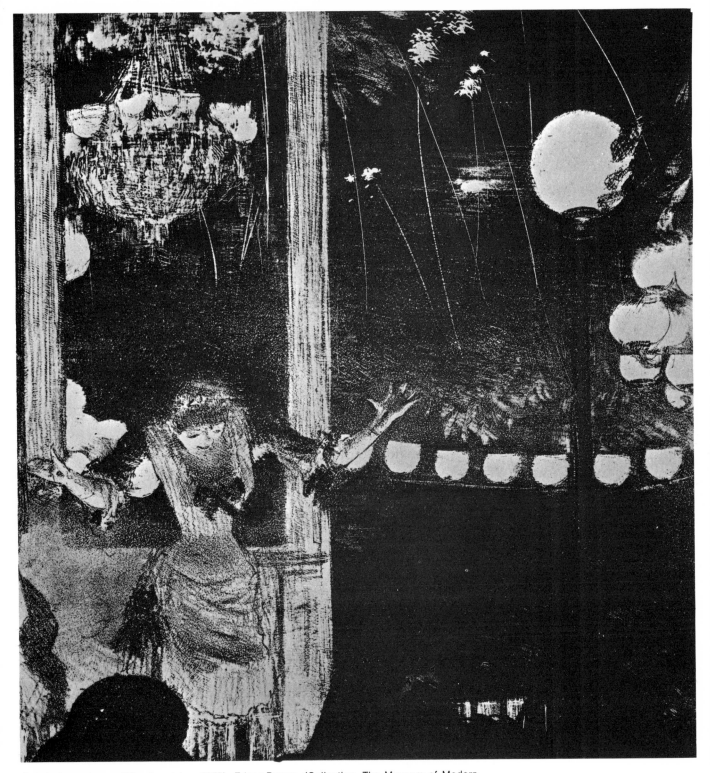

Aux Ambassadeurs: Mlle. Becat (ca. 1875), Edgar Degas. (Collection, The Museum of Modern Art, New York. Gift of Abby Aldrich Rockefeller)

graven image itself. Lithography, in contrast, is the freest of the multiple techniques. Its freedom is a result of the one-to-one congruence of the image applied by the artist to the lithographic surface and that which is finalized on the paper by the reliability of molecular adherence and transfer. This continuity of expression is particularly desirable today. Our visual statements, often more forceful, expansive, and urgently activated than those of previous eras, utilize the instancy and "neurology" of the creative act as an integral element of style itself.

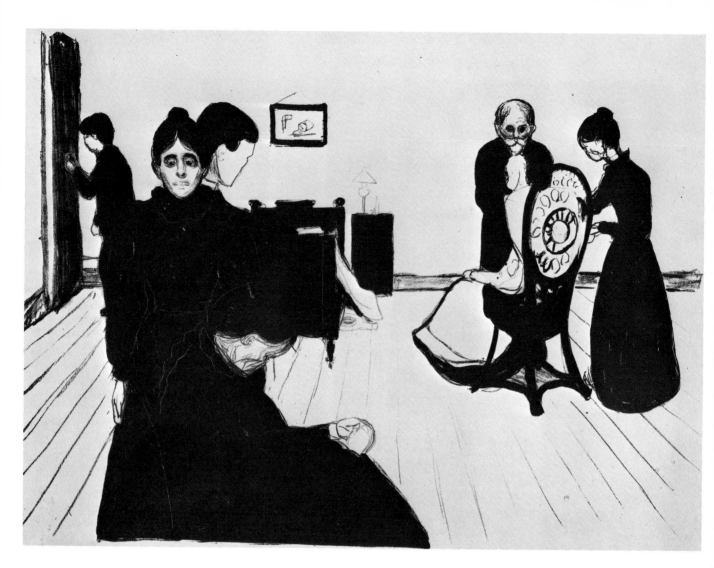

The Death Chamber (1896), Edvard Munch. (Collection, The Museum of Modern Art, New York. Gift of Abby Aldrich Rockefeller)

The range of effects that are unique to lithography—surface vibrancy and richness, the extraordinary textural range and the chromatic brilliance—set it apart not only from other printmaking techniques, but from painting and drawing as well. Rather than a poor second to these methods of creating one-of-a-kind images, lithography is a major and indispensable means of artistic expression. Only with this awareness should we then prize the second attribute of this technique—the creation of the multiple. The artist, collector, and museum curator rejoice at this phenomenon; the initial image, no matter how complicated it may be, can be *shared* through reproducibility or near-perfect repetition into the "edition." Whether the edition be five or five hundred impressions, the original graphic statement is there to be absorbed by the beholder. The making of the multiple, it is interesting to contemplate, is therefore a profound and responsible act of educational dissemination and cultural enrichment compatible with our humanitarian goals.

Lithography is only 170 years old, an upstart in the history of printmaking, which reaches back over 550 years. Invented by the German, Aloys Senefelder, in 1798, its use spread rapidly in the nineteenth century; encompassing the commercial world with its myriad of mercantile applications, it was employed by countless lesser artists and occasionally by those more accomplished It is almost incredible that such a simple physical law as oil not mixing with water, the basic formula of lithography, should permit such a kaleidoscope of graphic art to materialize. The first important painter to use the technique with

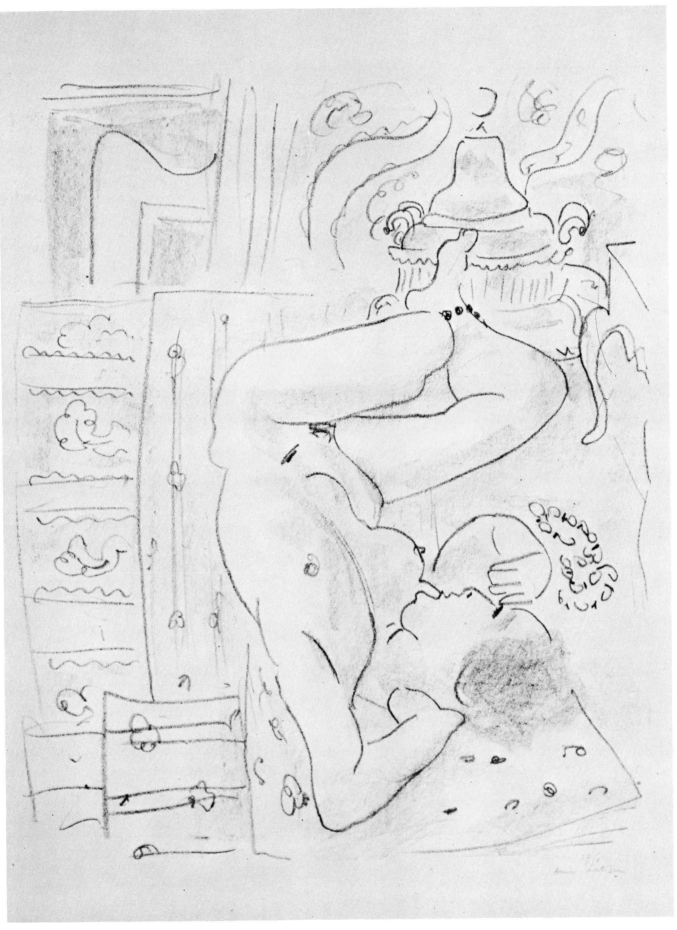

Reclining Nude with Stove (1929), Henri Matisse. (Courtesy of Martin-Gordon Gallery. Photo, Geoffrey Clements)

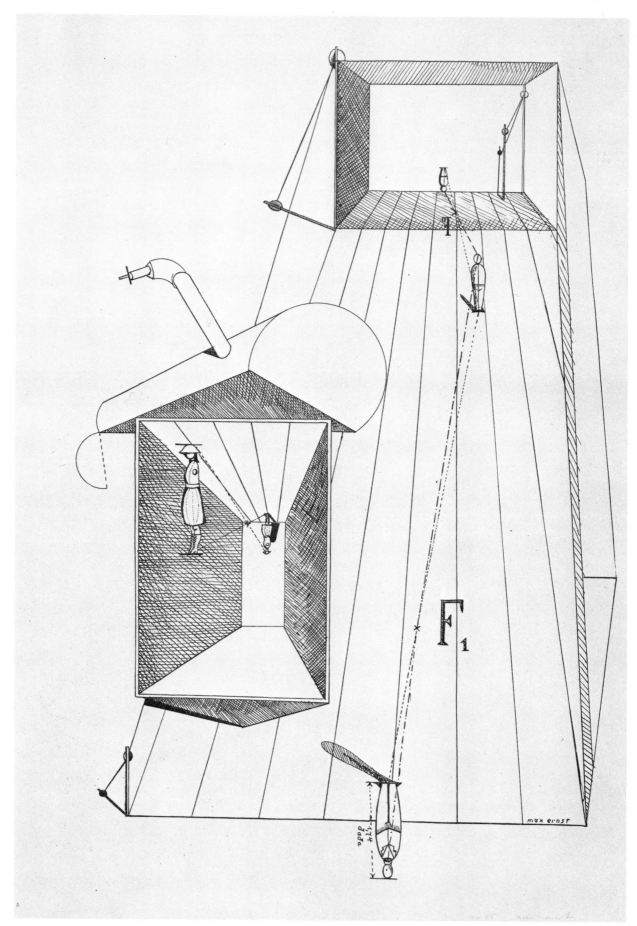

Fiat Modes, pereat ars (Let there be Fashion, down with Art) (ca. 1919), Max Ernst. Plate I of a set of eight lithographs and frontispiece. (Collection, The Museum of Modern Art, New York. Abby Aldrich Rockefeller Fund)

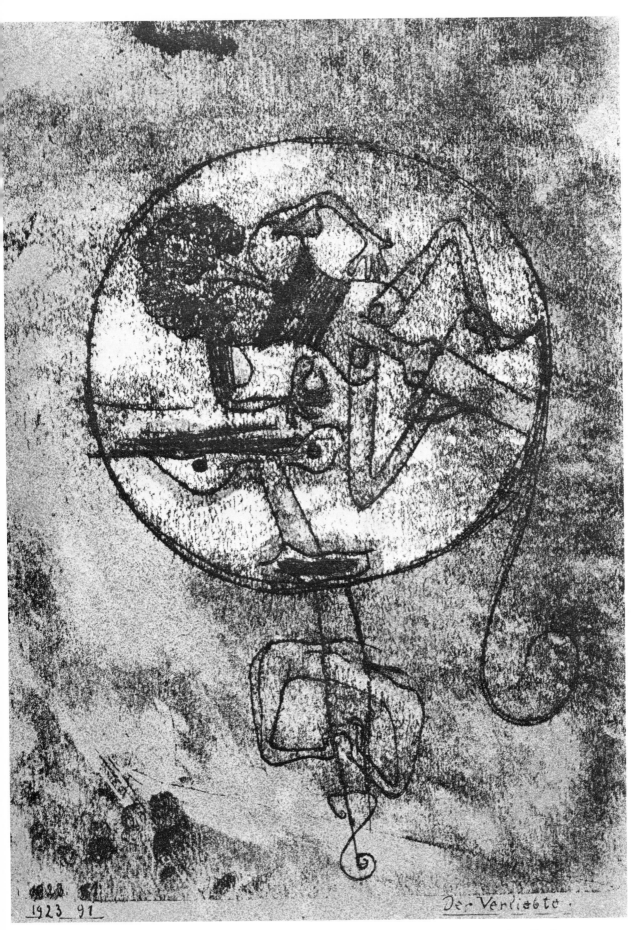

The One in Love (Der Verliebte) (1923), Paul Klee. (Collection, The Museum of Modern Art, New York. Purchase Fund)

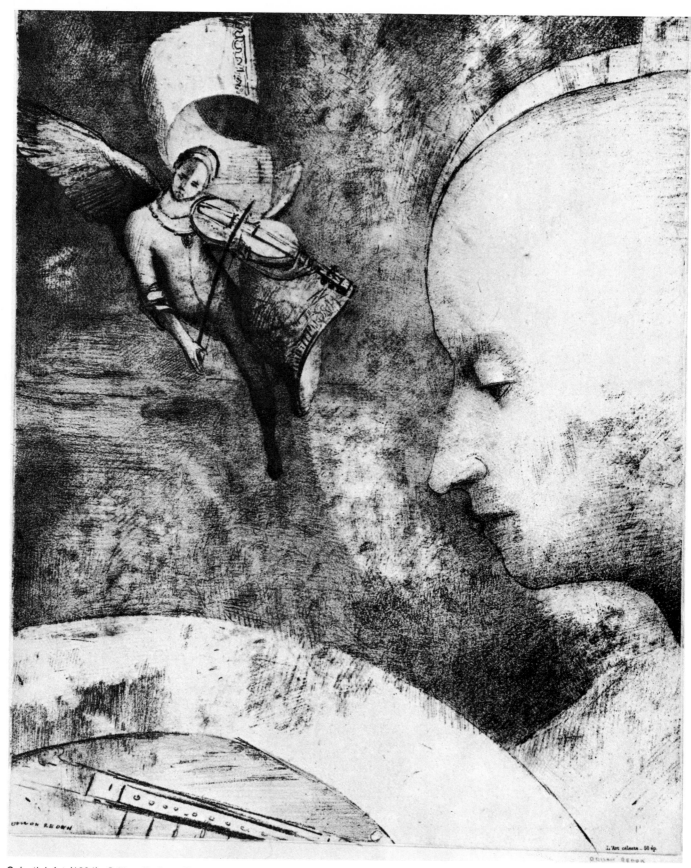

Celestial Art (1894), Odilon Redon. (Collection, The Museum of Modern Art, New York. Gift of Abby Aldrich Rockefeller. Photo, Geoffrey Clements)

Opposite:
Person in the Garden with a Red Moon (1951), Joan Miró
(Collection, The Museum of Modern Art, New York. Gift of Mr. and Mrs. Armand P. Bartos)

eminent success was Francisco Goya in his monumental series, "The Bulls of Bordeaux," of 1825. Others followed, such as Théodore Géricault, who pioneered the use of a color tint stone (in 1818); Edouard Manet, one of the first to create a full-paletted color lithograph (in 1874); Eugène Delacroix, Honoré Daumier, Odilon Redon, and a host of other prominent painters. Lithographic activity among master artists reached an intense pitch in the last decade of the century in France. Led by the colorist Henri de Toulouse-Lautrec, Pierre Bonnard, Edouard Vuillard, Auguste Renoir, Paul Signac, Paul Cézanne, and Maurice Denis, to name a few, caused a virtual renaissance in color lithography through their collaboration with printers and publishers such as Clot, Pellet, and Vollard. Over the millennium into our century, freer-styled expressionist color lithographs were produced by innovators such as Edvard Munch, Emil Nolde, and Ludwig Kirchner. More meticulous but often brilliant and intense were the color lithographs of Wassily Kandinsky and Paul Klee. In this country, George Bellows was the first artist of importance to use the technique extensively, Winslow Homer having made only a few lithographs in his youth and James McNeill Whistler, so successful with his "lithotints," being ensconced in England.

A new chapter in the history of lithography took place when Pablo Picasso began to work at the atelier of master-lithographer Fernand Mourlot in Paris after the liberation in 1945. Picasso's prodigious output and radical experimentation, and the efforts of Georges Braque and Joan Miró, became the inspiration for artists across the continent and in the United States. A proliferation of lithography workshops here in the 1950s and 1960s enabled scores of prominent painters and sculptors to turn to this medium for multiple images.

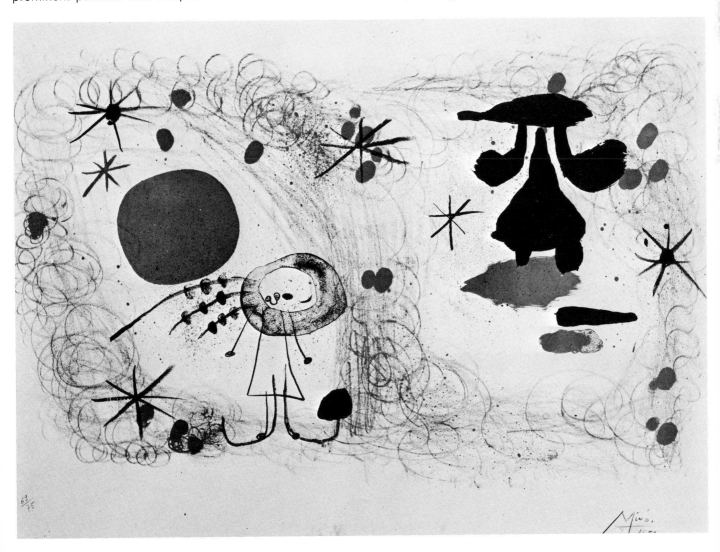

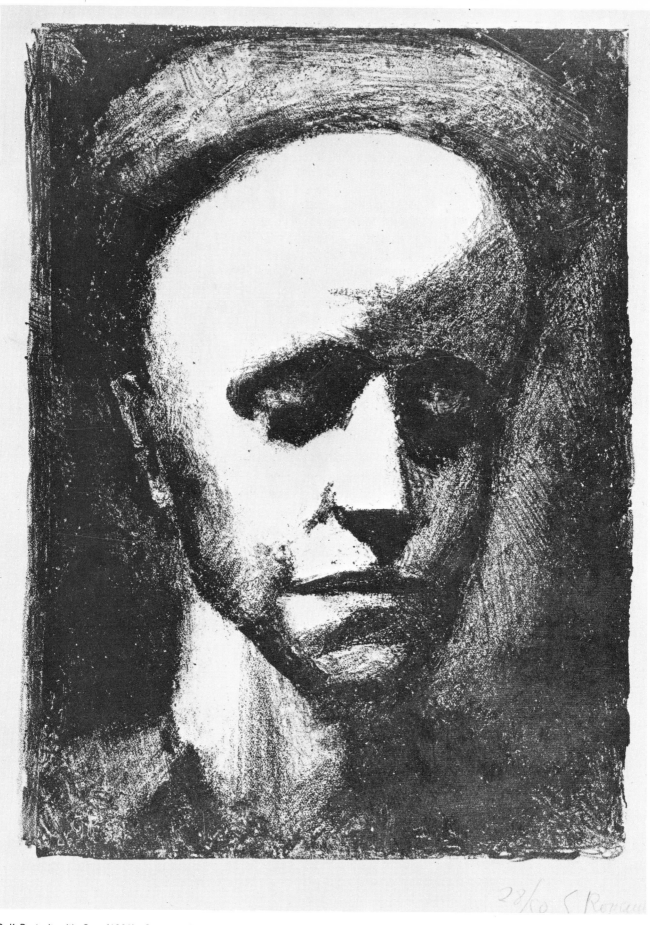

Self-Portrait with Cap (1926), Georges Rouault. (Collection, The Museum of Modern Art, New York. Gift of Abby Aldrich Rockefeller)

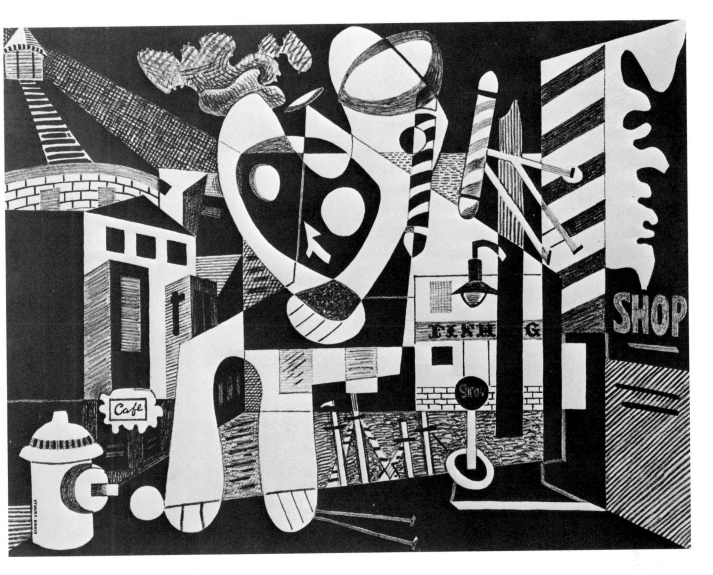

Barber Shop Chord (1931), Stuart Davis. (Collection, The Museum of Modern Art, New York. Gift of Abby Aldrich Rockefeller)

Meanwhile, original lithography became more widely used in Eastern Europe, in South America and in Japan, so that today its universal application as a primary means of expression is fully accepted and highly valued.

With the distinctiveness of the lithographic technique, its meteoric history, manifold experimentation, and present international use and acclaim, it is vital that there be an up-to-date and practical guide to its use for student and professional printmaker, for the printer himself, and for the collector and curator. The present volume is an attempt at such a step-by-step guide, written and presented in a clear and succinct manner, so that it can serve as a "working tool" of learning and first-hand application—a lithographic recipe book, so to speak, of not only the time-honored methods, but of the new, often mixed, techniques that have arisen out of successful contemporary experimentation.

As a collector, and as a juror of print exhibitions, I know how helpful it is to truly understand the "how" of the work I am viewing. For the printmaking aspirant, a thorough knowledge of the extraordinary lithographic technique and potential may open up equally extraordinary avenues of fruitful creativity.

Donald H. Karshan
President
Museum of Graphic Art

Health Hazards in Lithography

In 1975 an excellent article entitled "Health Hazards in Printmaking," by Michael McCann was published in *Print Review Magazine. Print Review* is published by the Pratt Graphics Center, New York. Excerpts from this article that pertain to lithography follow.

If you touch or inhale the solvents, acids, inks, or other chemicals used in lithography, you may suffer from some kind of occupational disease. The effect may be mild, for example, a minor irritation due to a mild acid burn, or it might be serious, for example, pulmonary edema (and maybe even pneumonia) resulting from an overdose of fumes from nitric acid etching. Even more insidious than the immediate or acute reactions are the long term or chronic diseases resulting from repeated exposure to small amounts of toxic materials. In many cases, it is difficult to say that one substance is responsible in an occupational disease as a variety of materials are usually present.

The actual hazards of working with a particular material depend on several factors: the amount of material you are exposed to, the actual toxicity of the material, the length and frequency of exposure, and your susceptibility.

HOW MATERIALS AFFECT THE BODY

There are three ways in which materials can enter and affect the body: 1) by skin contact, 2) by inhalation, and 3) through the mouth and digestive system.

A substance contacting the skin can damage the skin itself and/or can damage the internal organs when absorbed through the skin, e.g., benzol, ethylene glycol monomethyl ether acetate (which is found in many photoresists). Skin damage is of two types: direct irritation and contact dermatitis. Chemicals that directly irritate the skin affect everyone who has contact with the chemical. Acid burns and defatting caused by organic solvents are typical examples. Other chemicals called sensitizers cause allergies, creating contact dermatitis. Some sensitizers, for example, dichromate salts and turpentine, can readily cause allergies. In many cases, the allergy takes years to develop. These problems can be avoided by wearing gloves to prevent materials from coming in contact with the skin. Lined gloves are the best for comfort. Neoprene rubber gloves should be used for work with strong acids and organic solvents where particular sensitivity to tools and materials is not required. Disposable vinyl gloves can be used where sensitivity is needed and when using most organic solvents, except acetone and other ketones. If gloves cannot be worn, the use of barrier creams in combination with waterless hand cleaners will help prevent dermatitis. The choice of barrier cream depends on the materials being handled. If some contact with solvents is unavoidable, the use of lanolin hand lotions will help prevent injury.

The second way substances enter the body is through inhalation of dusts, vapors, mists, or fumes. Effects can vary from temporary headaches, caused by exposure to many organic solvents, to the more serious lung diseases resulting from inhala-

tion of excessive amounts of gases from nitric acid etching. Long-term effects include pulmonary fibrosis (lung scarring) from repeated exposure to carbon arc gases and possible silicosis, asbestosis, or lung cancer from repeated exposure to silica and asbestos-containing materials (e.g., many talcs). One of the most important factors with dusts is the size of the particles. Fine particles are more toxic because they penetrate deep into the lungs. Larger particles get trapped by the mucus in the nose and upper breathing passages where they can be swallowed or spit out.

Many substances, especially solvent vapors, are somewhat soluble in the blood and can travel to other internal organs. This can result in toxic effects on many parts of the body, especially the liver, kidney, blood, and central nervous system.

The third area of exposure to toxic materials is through the mouth and digestive system. This is a relatively common area because people contact their mouths with contaminated hands, food, and cigarettes. This makes it particularly important not to eat where you are working and to be careful to clean your hands.

Lithography uses counter-etches, litho crayons, tusche, desensitizing "etches," "wash-outs," fountain solutions, cleaning solvents, etc.

Counter-etches

Metal plates use counter-etches to sensitize the plates to the drawing grease. These usually consist of weak acid solutions of alum. Alum might cause mild dermatitis or allergy. Hydrofluoric acid, also sometimes used as a counter-etch for aluminum, is hazardous, especially if inhaled.

Drawing

Litho crayons used for drawing contain wax, soap, and lampblack, and sometimes shellac. Litho tusche consists of the above dissolved in turpentine and emulsified in water.

Desensitization

Before applying the desensitizing etch the plate is dusted with talc (talcum or French chalk) while the stone is dusted with talc and powdered rosin. Talc contains asbestos and silica which can cause severe chronic lung problems and lung cancer. An analysis of one commercial French chalk, for example, indicated it contained 40 percent asbestos. *Note:* Use Johnson's baby powder instead.

Desensitizing or gum etches contain gum arabic with a variety of other chemicals, usually acids. These include nitric acid (for stone), phosphoric acid, tannic acid, dichromates, chrome alum, like dichromates, can cause severe dermatitis, ulcerations, and severe allergy reactions. Ammonium nitrate, though nontoxic, is dangerous because of its explosive properties. Gum arabic is probably safe under normal use, although inhalation of gum arabic mists formerly used in offset printing caused a disease called "printers asthma."

Solvents

Old ink or crayon is washed out with turpentine or lithotine (turpentine and mineral spirits) and tincture of asphaltum (asphaltum in mineral spirits). Fountain solutions usually contain dichromates.

In lithography a variety of lacquers and cleaning solvents are used. Most of them contain solvents like ketones, methanol, toluol, and mineral spirits. Since many of these, especially methanol and toluol, are toxic, they should be handled with good ventilation. Some cleaners like Hanco glaze cleaner, also contain large amounts of benzol. They should be avoided because of the extremely high toxicity of benzol. Nitrobenzene, used in one plate lacquer, is a serious liver, blood, and nervous system poison, and is especially dangerous since it can be absorbed through the skin and clothing.

TABLE 1 TOXICITY OF SOLVENTS

Alcohols
Typical Solvents
methanol (wood or methyl alcohol)
ethanol (ethyl or grain alcohol)
propyl alcohol
butyl alcohol
amyl alcohol

Hazards
Vapors are mildly narcotic and are irritating to eyes, nose, and throat. Methanol if swallowed is poisonous causing blindness and death. If inhaled, causes intoxication, nausea, headaches, vision problems, etc. Ethanol is safest alcohol. Denatured alcohol is ethanol with at least 5-percent methanol. Amyl alcohol also quite toxic.

Uses
present in lacquer thinners, paint thinner, spray fixative

Aromatic Hydrocarbons
Typical Solvents
benzol (benzene)
toluol (toluene)
xylol (xylene)
styrene

Hazards
All are potent narcotic agents and over-exposure can result in loss of muscular coordination, collapse, and unconsciousness. Benzol is most toxic, and is a cumulative poison, causing liver damage, bone marrow destruction (leading to anemia), and leukemia. It can be absorbed through skin. Xylol and toluol are less toxic and can be used to replace benzol.

Uses
paint and varnish removers, lacquer solvent and thinners, silkscreen washup, litho cleaning solvent, photo-etch solvent

Chlorinated Hydrocarbons
Typical Solvents
carbon tetrachloride
chloroform
ethylene dichloride
methyl chloroform
trichloroethylene
methylene dichloride (dichloromethane)

Hazards
All can produce narcotic effects and are strong skin defatters. Many also cause severe liver and kidney damage, and some are nervous system poisons. In general quite toxic, with carbon tetrachloride, chloroform being most hazardous. Safest ones to use are methyl chloroform and methylene dichloride with excellent ventilation needed. Can't smell most of them until dangerous level is reached.

Uses
degreasers, solvents for waxes, oils, etc., solvent in some aerosol sprays; methylene dichloride used in some paint and varnish removers

Esters
Typical Solvents
methyl acetate
ethyl acetate
butyl acetate
amyl acetate
glycol ether acetates
 (see glycol derivatives)

Hazards
Eye, nose, and throat irritants. No serious skin problems. Not a serious health hazard, since odor warns you.

Uses
lacquer solvents and thinners, silkscreen film adhering liquids

Glycol Derivatives
Typical Solvents
methyl cellosolve (ethylene glycol monomethyl ether)
methyl cellosolve acetate
cellosolve (ethylene glycol monoethyl ether)
cellosolve acetate
butyl cellosolve

Hazards
Glycol derivatives can be absorbed through the skin and the vapors are irritating. Methyl cellosolve (and its acetate) are highly toxic and can cause anemia, other blood abnormalities, and nervous system disorders. Cellosolve is less toxic, but inhalation of large amounts can cause severe lung and kidney problems.

Uses
lacquer and ink solvent; methyl cellosolve acetate solvent in KPR photo-resist

Ketones
Typical Solvents
acetone
methyl ethyl ketone (MEK)
methyl iso-butyl ketone (MIBK)
isophorone

Hazards
Generally of low toxicity, especially acetone. Irritating to eyes, nose, and throat and high concentrations can cause narcosis Odor is a good warning signal. Ketones are strong defatting agents and may cause dermatitis. Isophorone is quite toxic and extreme care should be taken with it.

Uses
lacquer solvent, plastic solvent, cleaning solvent

TABLE 2 TOXICITY OF ACIDS

Petroleum Distillates
Typical Solvents
petroleum ether
petroleum naptha
gasoline
benzine (VM&P naptha)
mineral spirits
varnolene
varsol
kerosene

Hazards
Generally of low toxicity. Inhalation can cause narcosis and headaches, and large amounts, especially by aspiration, can cause chemical pneumonia. Kerosene is also strong skin irritant and strong lung irritant.

Uses
inks, lacquers, etching ground, aerosol spray, rubber cement and thinner, paint thinner, lithotine component

Miscellaneous
Typical Solvents
ether (ethyl ether)
turpentine

Hazards
An anesthetic. Nose and throat irritant, causes loss of appetite, excitation, and drowsiness. Dries skin and can cause dermatitis.

Skin irritant and sensitizer. Inhalation of large amounts causes irritation of eyes, nose, and throat, headaches, gastritis, anxiety.

Uses
etching ground

paint thinner and solvent present in lithotine

Acetic Acid
Hazards
Corrosive to skin. Repeated exposure to vapors can cause chronic bronchitis.

Chromic Acid and Salts
Hazards
Chief danger is to skin and nasal membranes. Causes allergic skin reactions and deep, slow-healing ulcers when skin is broken. Can severely damage nasal membranes, even to extent of perforating nasal septum. Inhalation of chromic acid vapors can cause severe chemical pneumonia, and exposure to chromium compounds can cause lung cancer after twenty–thirty years.

Hydrochloric Acid
(hydrogen chloride, muriatic acid)

Hazards
Vapors have detectable odor at threshold danger level. Aqueous solutions are corrosive and vapors are irritating to respiratory tract. Extensive exposure can cause pulmonary edema.

Hydrofluoric Acid (hydrogen fluoride)
Hazards
Highly irritating and corrosive to skin and mucous membranes. Skin burns, if not treated, can ulcerate. Vapor is poisonous.

Nitric Acid
Hazards
Dangerous. Attacks eyes, skin, and mucous membranes. Fumes from etching contain nitrogen dioxide which dissolves in lungs to produce nitric acid. Large exposures can cause pulmonary edema and even death. Can also cause chronic lung diseases.

Phosphoric Acid
Hazards
Very corrosive to skin.

Sulphuric Acid (oil of vitriol)
Hazards
Gives off sulfur trioxide and sulfuric acid mist when concentrated; both are irritating to respiratory tract. Overexposure similar to hydrogen chloride, and may cause permanent lung scarring and emphysema. Solutions strongly corrosive to skin and teeth.

Equipment

LAYOUT OF THE LITHOGRAPHIC WORKSHOP

When the physical layout of a lithographic workshop is planned, the shape and size of the room, load-bearing ability of the floor, plumbing facilities, and adequate lighting must be taken into account. Figure 1-1 shows an ideal design with several distinctive features that are of critical importance. For example, in the positioning of the graining rack, care should be taken that it is close to the stone storage facilities (Figure 1-2) and also easily accessible to both presses and work tables. A small sink placed near the presses will be an invaluable aid. The graining rack, the movable stone tables, and the work tables all should be the same height. A small hydraulic lift is a godsend when handling large litho stones. Carefully plan where each part of the process from inking to drying of the proof will take place, as this will minimize unnecessary steps and influence the cleanliness of the finished print. For speed and efficiency, storage racks above the printing area (Figure 1-3) should contain all the chemicals and inks needed for the printing process.

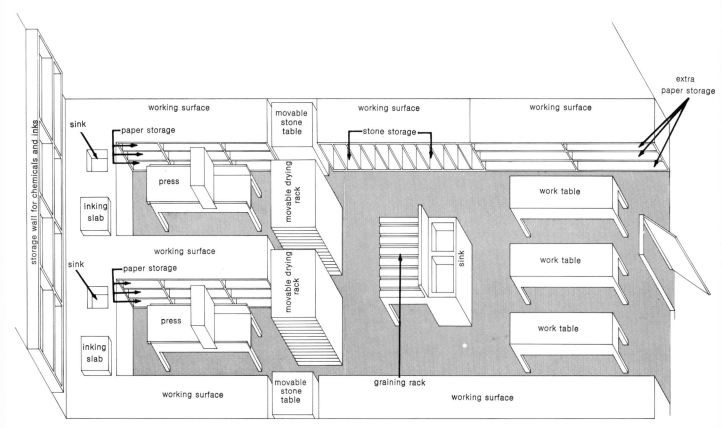

1-1 Layout of the lithographic workshop

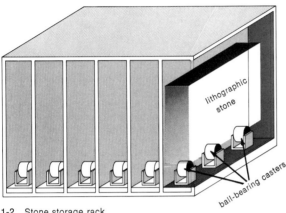

The stone storage rack at left can be designed to house heavy stones in a horizontal position. This allows them to slide out directly onto a movable table or lift cart.

1-2 Stone storage rack

1-3 The printing area

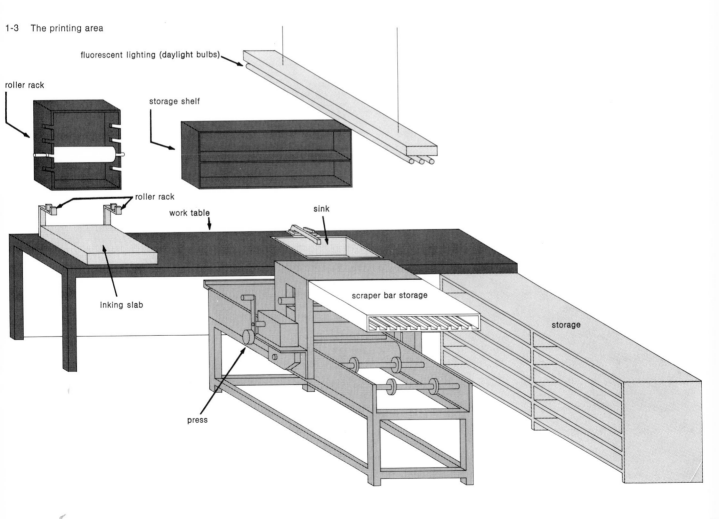

LITHOGRAPHIC PRESSES

The three most common presses in use in the United States are the Fuchs and Lang press, the Brand press, and the European press (Figures 1-4, 1-5, 1-6). Though they differ in detail, all three are basically unchanged since the early days of lithography. Apart from contemporary innovations such as gear reduction systems and motorization, the primary difference between the Fuchs and Lang press and the Brand and European presses is in the placement of the cylinder. In the latter, the cylinder remains in place while the pressure lever moves the scraper bar down to make contact with the stone. On the Fuchs and Lang press, the pressure lever raises the cylinder, bringing it into contact with the press bed, thereby bringing the stone into contact with the scraper bar.

The diagram of the Fuchs and Lang press illustrates individual components and their functions.

Side frames of cast iron (*a*) are bolted together by supporting cross sections (*b*). A screw hole is drilled through the yoke (*c*) into which is fitted the pressure adjusting screw (*d*) whose end attaches to the scraper bar holder (*e*). The scraper bar holder is free at both ends, remaining self-adjustable to the stone when pressure is applied. The scraper bar is held in place by a screw at the back of the scraper bar holder. The press bed (*f*) is made of well-seasoned, laminated hard wood about 2″ thick. The undersurface has iron strips, which bear the pressure during working time. On each side of the press bed are runners which allow the bed to roll freely on iron rails, located on the inside of each of the frames. The lever (*g*) consists of three parts: the handle, the connecting rod, and the oval cams. When the handle is lowered, the cylinder (*h*) is brought into contact with the underside of the press bed. The handle (*i*) is attached to the roller which, when turned, moves the press bed.

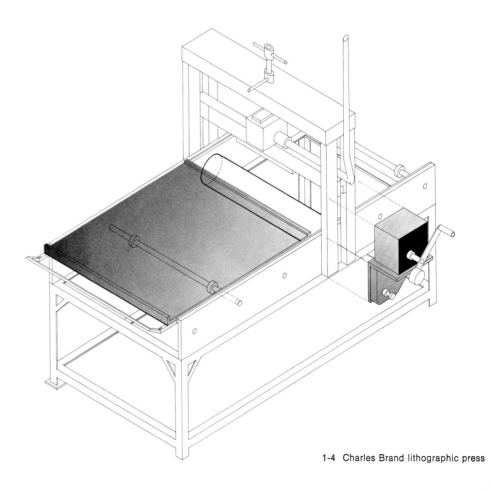

1-4 Charles Brand lithographic press

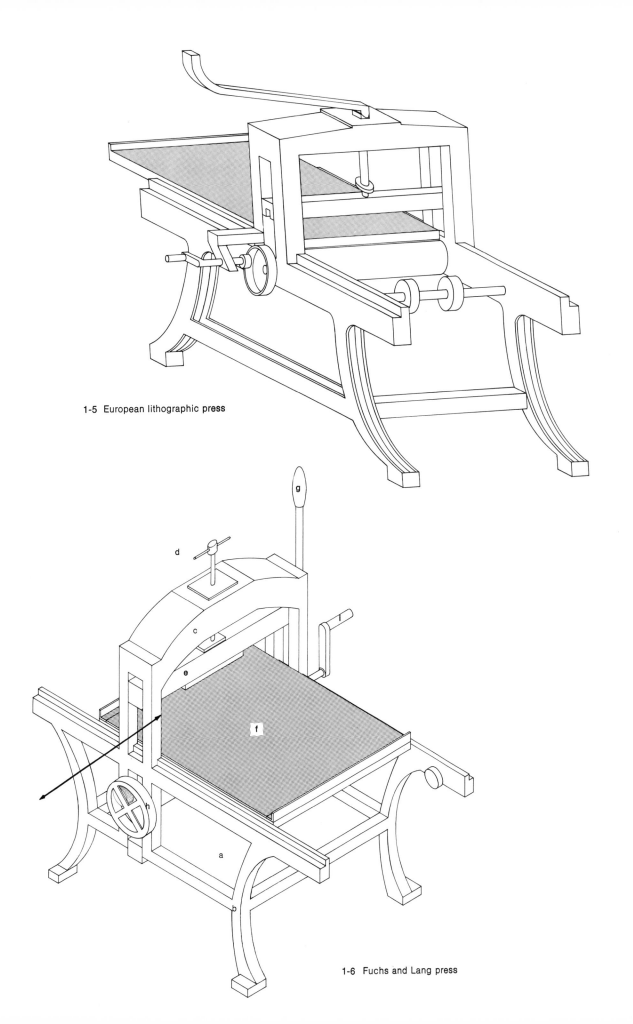

1-5 European lithographic press

1-6 Fuchs and Lang press

All lithographic presses must be oiled and greased regularly to insure smooth running. Be careful to keep the grease from falling onto the cylinder, because it will reduce the friction, forcing the bed to slip. The press should be cleaned regularly to remove rosin, talc, and gum drippings which accumulate on the runners and cylinders. The press bed should be checked periodically for evenness, since an uneven press bed causes uneven printing and stone breakage. It is wise to place a sheet of battleship linoleum or heavy rubber on the press bed to absorb excess pressure and possible unevenness of the litho stone.

TYMPANS

The tympan is a smooth, flat sheet placed between the blotter and the scraper bar. It must be made of a material which is smooth, non-absorbent and able to withstand, without stretching, the enormous pressure exerted by the press. Many materials serve effectively as tympans, but linen-coated phenolic resin sheets approximately 1/32″ thick are ideal. These sheets are called G-10 epoxy in the commercial plastics industry. If this material is not available, the ungrained side of an old zinc or aluminum plate may be used instead. Be sure that the tympan covers not only the stone but the blotter and printing paper as well. It is imperative that the tympan be kept free of dirt and grime, because impurities may incise the tympan, the scraper bar, or the surface of the stone or plate. The secret of a well-functioning tympan is in the smoothness of its surface. Use liberal quantities of a lubricant such as cup grease or vaseline on the upper surface of the tympan to reduce surface friction.

1-7 Scraper bar

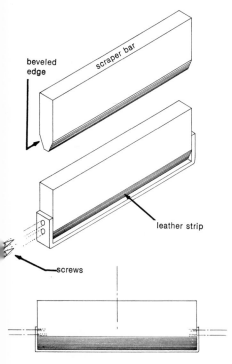

beveled edge

scraper bar

leather strip

screws

SCRAPER BARS

Each press demands a specialized scraper bar, though the general characteristics of all scraper bars are similar. The bars must be of a hard material such as boxwood, hard rock maple, or a synthetic such as Benelux. A good lithographic studio should have an assortment of scraper bars large enough to cover the stones and plates used in that shop.

If the edges of the stone have not been rounded properly, and the scraper bar extends beyond its surface, it will incise the leather covering of the bar and ruin its surface.

The general construction of the scraper bar is shown in Figure 1-7. The scraper bar is at least ¾″ thick and approximately 2½″ high, with the beveled top edge ¼″ thick. Screw holes should be drilled on either side of the scraper bar. Finally, a piece of leather 1½″ wide and free from imperfections, long enough to cover the scraper bar, should be prepared. Soak the leather in water until it is fully saturated; then place the scraper bar in a vise, screwing one side of the leather to the bar. With a strong pair of canvas-stretching pliers or vise-grip pliers, stretch the leather as tightly as possible over the bar and secure it. Trim the edges of the leather adjacent to the screw holes, but do not trim the leather that overhangs the beveled edge. Trimming keeps the scraper bar in the correct position when it is secured onto the press. After the leather has dried, coat the entire surface with grease, which will penetrate in time. The bar is now ready for use.

The Night Game/Self Portrait, 22 × 30. Andrew Stasik. Lithograph with Screen print and Stencil. (Photo, Arthur Swager)

LITHOGRAPHIC ROLLERS

A quality lithographic workshop must have a selection of rollers to handle the many jobs confronting the artist-printer. There are two types of rollers: leather rollers for black-and-white printing, and rubber or composition rollers for color printing (see Figure 1-8). A variety of each type is essential.

The size of the rollers is determined by the size of the plates or stones used in the shop. Ideally, the roller should be longer than the image to be printed and smaller than the plate or stone. Smaller composition rollers and brayers are effective for spot-printing of color work. Remember, it is impossible to produce an acceptable print without well-cared-for rollers.

The density of rubber rollers is measured in durometer reading. A reading of 20 or 30 is most commonly used in hand lithography. Recently polyurethane rollers have proved to be highly reliable and are beginning to replace synthetic rubber rollers.

1-8 Types of rollers

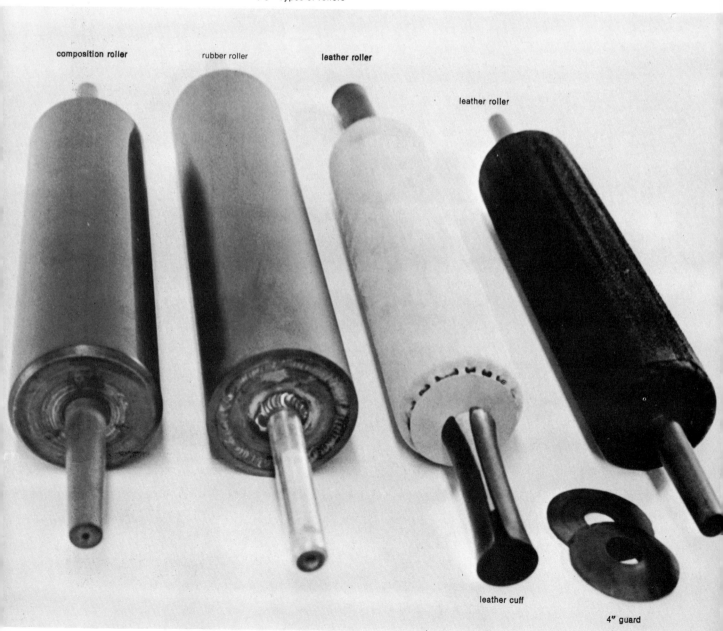

composition roller rubber roller leather roller leather roller

leather cuff

4" guard

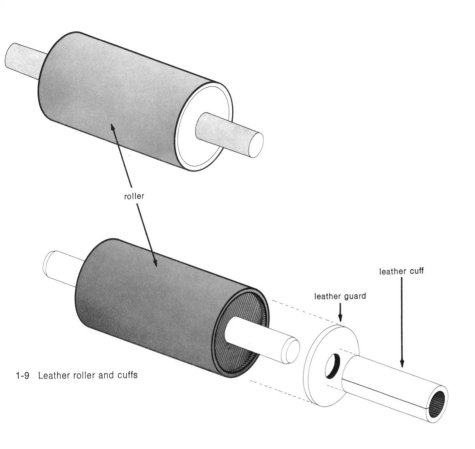

1-9 Leather roller and cuffs

1-10 Roller storage rack

Conditioning Leather Rollers

All new leather rollers must be conditioned before use. This is done by lightly sanding the exterior of the leather roller with a very fine sandpaper. Continue this process until the nap is reduced to a velvety texture.

Spread #00 varnish onto the inking slab. Place leather cuffs and circular leather guards on the roller to protect hand and knuckles (see Figure 1-9). Keep turning the roller in the varnish until its outer surface is evenly saturated, a process which may require several days of treatment depending on the absorbency of the leather. Store the roller in plastic wrap or waxed paper and aluminum foil in a roller rack (Figure 1-10) until the roller is judged ready for the next step.

When the roller is fully saturated with #00 varnish, scrape the leather against the grain with a long, flexible spatula (see Figure 1-11). Be sure to remove the leather cuffs and guards before scraping; then secure one end of the roller and hold the other end against the abdomen to facilitate the process.

Spread #8 varnish (a very tacky substance) on the surface and continue rolling to further remove the nap. As the varnish begins to become saturated with bits of nap, clean and scrape the ink slab and roller. Repeat this operation over a period of several days until most of the nap has been removed. Again, as this step takes time, the roller should be stored in plastic wrap or waxed paper and aluminum foil while not being worked on.

Finally, scrape the roller, spead out a quantity of black roll-up ink on the slab, and begin rolling up. The excess nap will continue to be removed simultaneously, beginning the transformation from a varnish-saturated roller to an ink-saturated roller. Scrape the roller as often as possible to hasten the removal of superfluous nap. Continue scraping until the roller no longer gives off nap. When the surface of the roller takes on a velvety appearance, it is ready for use in the proofing and printing stages. Wrap the ink-saturated roller in waxed paper and aluminum foil and place it in a roller rack.

1-11a
Roller-scraping spatula

1-11b
Scraping the leather roller

spatula

Storage of Leather Rollers

If a roller is used frequently (every two or three days), coat it completely with roll-up ink and wrap it up for storage as just described.

For long-term storage, the roller should be well scraped, and tallow, vaseline, or grease rubbed into the surface. This protects the leather from drying out and hardening. Wrap the roller with plastic wrap or waxed paper and aluminum foil.

Before you use the roller again, completely remove the tallow from the leather with gasoline and a suede brush and scrape the roller both with and against the nap until all traces of the solvent are gone.

Reconditioning the Leather Roller

If ink has accidentally been allowed to dry on the leather, the roller will have to be reconditioned. First saturate the leather roller with paint remover, scrubbing with a suede brush until the dried ink begins to loosen. Immediately wash off the paint remover with alcohol and repeat the process. Then remove excess alcohol by rolling out on newsprint, and rub tallow or a commercial leather conditioner over the surface. Finally, wrap the roller and store it for a day or so. Inspect the roller periodically until the tallow on the surface of the roller has softened the nap and restores the uniform velvety appearance necessary for quality printing.

Composition and Rubber Rollers

There are many types of rubber and composition rollers available commercially. Composition rollers usually are made from gelatin formulas and have a tendency to lose their shape. Rubber rollers are fast being replaced by those of synthetic materials, which are far superior for shop work. Both synthetic and rubber rollers have an aluminum core, are light in weight, and are easily manipulated. They are marketed in various diameters and lengths. Color printing demands careful consideration of roller diameter, since large diameters prevent repeating images on other areas of a stone.

These rollers can be cleaned easily with readily obtainable solvents, so that making color changes during printing is a simple procedure. They should be cleaned immediately upon completion of a run to prevent ink from drying on the surface and stored in a roller rack.

1-12
Steel levigator

LEVIGATORS

A levigator (Figure 1-12) may be substituted for a second litho stone in the graining procedure. (Graining is fully discussed in the next chapter.) When graining a very large stone, this implement is faster and easier to handle and achieves the same results as two stones. A levigator is a steel disc approximately 1' in diameter and 1¼" thick, with both top and bottom edges beveled to ⅛". All sides have a smooth surface finish. The handle is screwed into the base and fastened by a set screw. A steel sleeve sits on top of the handle and may include bearings which permit circular rotation of the levigator.

There are also commercial stone-graining machines available. However, they are costly and generally not found in the average lithographic workshop.

GRAINING RACKS

The graining rack (Figure 1-13) should be made from durable materials such as plastic or hard wood lined with an epoxy resin or sheet metal. It should be capable of supporting heavy loads. Be sure that the drainage pipe is at least 5″ above the bottom of the rack to prevent the carborundum used in graining from clogging the drain.

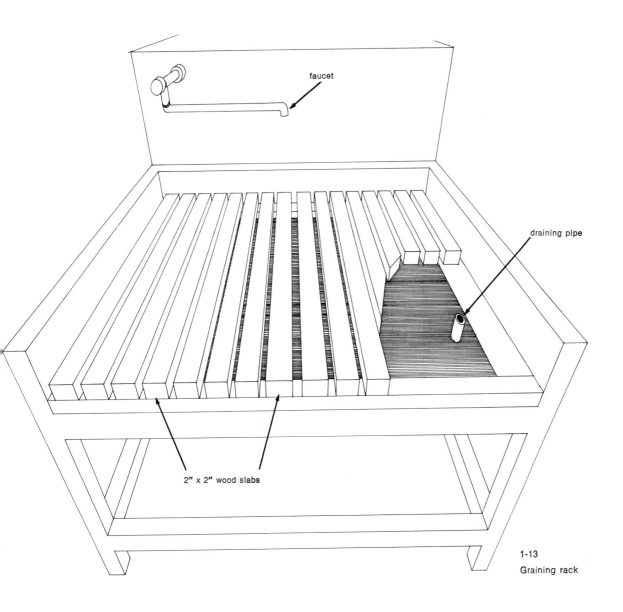

faucet

draining pipe

2″ x 2″ wood slabs

1-13
Graining rack

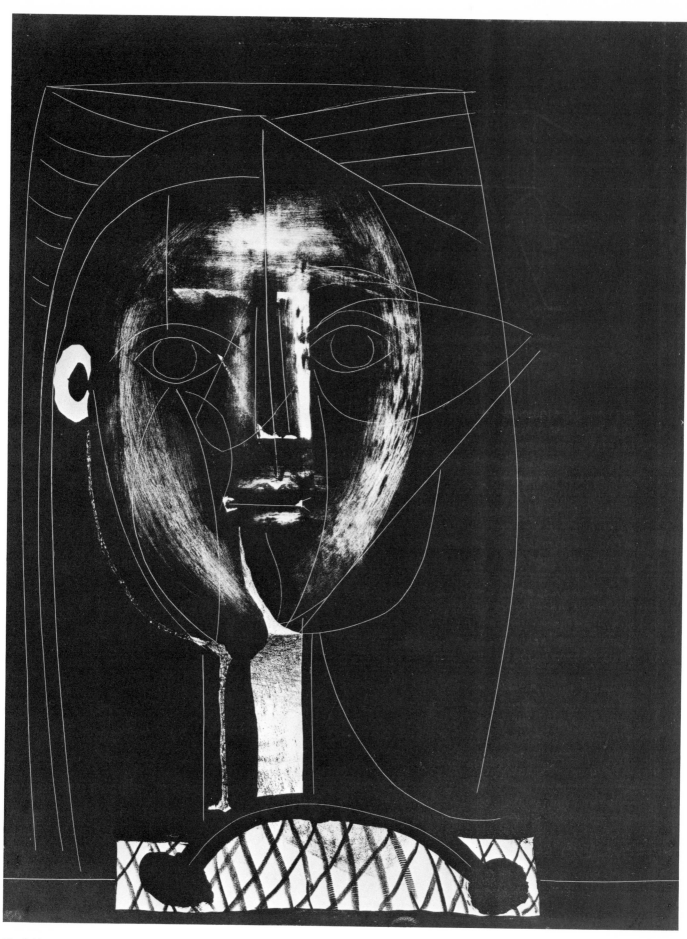

Black Head—Figure Noire (November 20, 1948), Pablo Picasso. (Collection, The Museum of Modern Art, New York. Gift of Abby Aldrich Rockefeller)

The Lithographic Stone CHAPTER 2

CHEMICAL AND PHYSICAL PROPERTIES OF THE STONE

Lithographic stones are almost pure limestone, consisting of 94 to 98 percent calcium carbonate. They range in color from blue-grey to yellow. The color of the stone indicates its quality. The greyer stones are more desirable because grease penetrates them more uniformly; they are older, harder, and more dense, and have the ability to accept a very fine grain. The yellow stones are softer and cannot be grained as fine, which may cause printing problems.

The surfaces of some lithographic stones contain easily recognizable impurities such as chalk marks, silicon veins, and iron stains. These defects may affect the image during printing, depending on their size and type and the area they cover.

Lithography is based on the principle of the antipathy of grease and water. The litho stone has a natural affinity for grease. The image to be reproduced is drawn on the stone with a greasy material. In order to retain the drawn image and desensitize the blank areas (make them ink-repellent and water-receptive), the stone must be etched with a gum arabic and nitric acid solution, which combines with the calcium carbonate of the stone to produce oleomanganate of lime. The nitric acid opens the pores of the stone, enabling the gum and grease to enter easily. The gum arabic surrounds the greasy sections, forming an insoluble surface film which clings to the non-printing areas and the valleys or interstices of the grain (see Figure 2-1). This coating surrounding the image attracts water applied during printing It will not wipe off, and it prevents the grease from spreading sideways and blurring the image.

Because of the antipathy of grease and water, the image will attract oily ink as it simultaneously repels water. Thus, when the stone is dampened and an ink-charged roller is passed over it, a film of printing ink is deposited onto the greasy drawing, but not on the remainder of the stone.

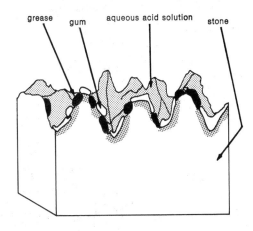

2-1

Diagram of etched lithographic stone

grease gum aqueous acid solution stone

GRAINING THE STONE

Graining (Figure 2-2) is the first step in the preparation of a stone to receive a drawing. This sensitizes the stone by removing dirt and grime and all previous greasy images which have penetrated the surface. Production of a specific grain is the most important reason for this process. The grain provides the tooth for the drawing material and serves as a water reservoir in printing.

2-2 Graining with a levigator

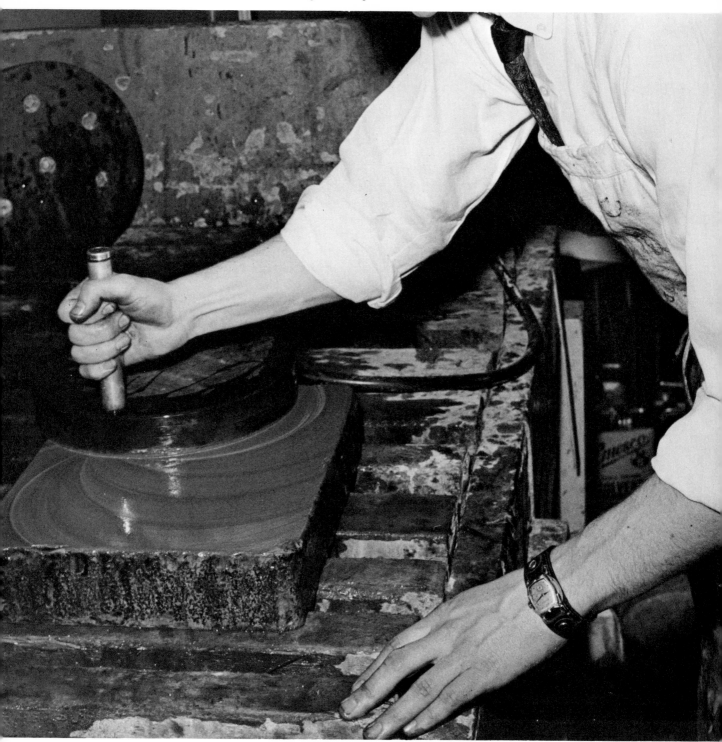

Method

1. Remove old ink from stone with solvent.
2. Round stone edges with file.
3. Cover stone with water; sprinkle #80 carborundum evenly over entire surface.
4. Place dampened levigator or second stone on prepared surface; proceed to grain according to the pattern described in Figure 2-3.
5. Grind carborundum to pulp state (greyish white in color).

Supplies

Litho stone and a levigator with an upright handle or two litho stones of similar size
Solvent
Metal file
Carborundum of various grades (#80—coarse; #150—medium, #220—fine)
True steel straightedge
Calipers

2-3 Figure-8 graining pattern

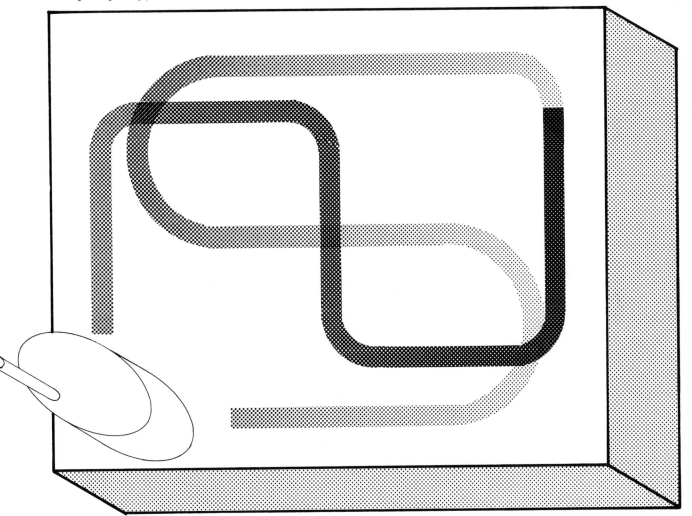

6. Wash stone and levigator or second stone carefully (see Figure 2-4). Make sure all used carborundum has been removed.
7. Repeat steps 3 through 6 with #80 carborundum until removal of old image is completed.
8. Clean all equipment and stone before proceeding to higher-grade carborundum. *Note:* Severe scratching will occur if any particles from a coarser grade of carborundum remain on the surface of the stone.

2-4
Washing the grained stone

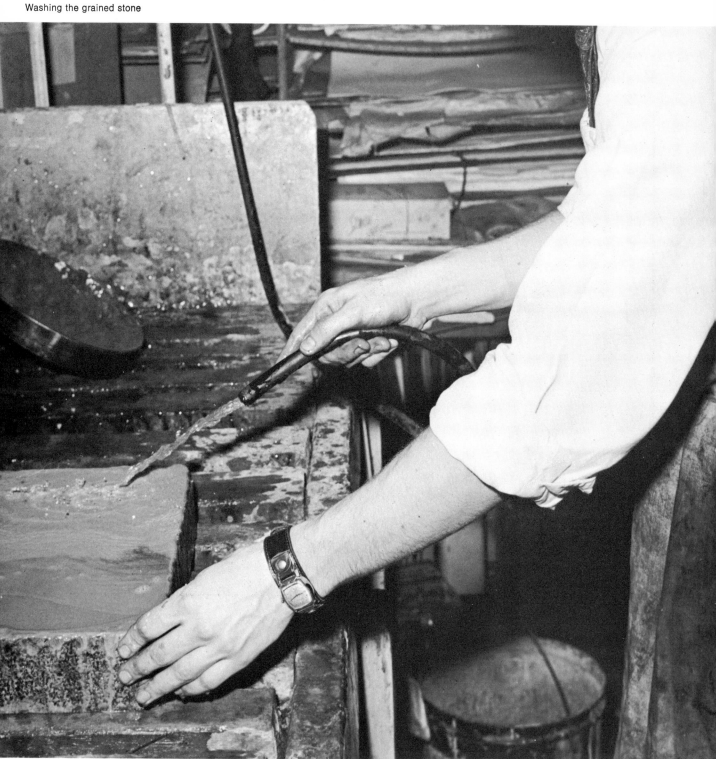

9. Repeat graining procedure at least three times with each grade of carborundum. However, for a coarse grainy effect, stop graining after treatment with #80 or #150 carborundum.
10. Dry stone completely.
11. Check the surface of the stone by placing straightedge across the surface, as shown in Figure 2-5. To determine that the stone is perfectly flat, insert three small pieces of tissue paper beneath the straightedge. The stone is hollow wherever the tissues can be removed easily. Also check that the stone is uniformly thick by using calipers at various points around the stone.

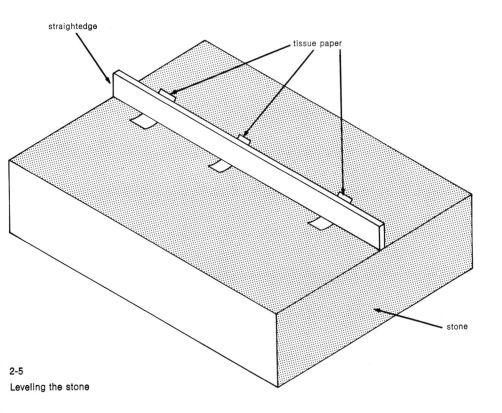

2-5
Leveling the stone

Drawing and Erasing Materials

The most common drawing materials and implements employed in lithography are described in this chapter. The primary substance in all litho drawing materials, whether they are liquid or solid, is grease. Pigments, such as carbon blacks, are another ingredient. Figure 3-1 illustrates some of the effects that can be achieved with different drawing materials on a litho stone.

LITHO CRAYONS AND PENCILS

Litho crayons and pencils contain wax, pigment, soap, and shellac. The shellac content determines the grade of the crayon or pencil. The higher the number, from 00 to 5, the harder the crayon or pencil is. To emphasize the grain of the stone or plate, use a harder crayon. Both drawing materials may be used with water to form dense lines or washlike effects. Litho crayons and pencils may also be dissolved in turpentine to create specialized wash effects. Ordinary wax crayons produce similar results, but there is no choice of grades because they do not contain shellac.

LIQUID TUSCHE

Liquid tusche, a water-soluble solution, is composed of the same materials (except shellac) as lithographic crayons and pencils. It is used to produce a complete range of washes as well as solid tones. Because of the impurities in tap water, distilled water is recommended for mixing washes. By combining tusche with solvents such as turpentine, alcohol, lacquer thinner, lighter fluid, etc., various textural washes may be obtained. Igniting the alcohol and tusche combination will produce an exquisite wash. When using alcohol and tusche, be sure not to dilute the tusche with water, or it will not ignite. *Note:* Do not use this technique on zinc plates that have been regrained many times, since they may bubble under the heat.

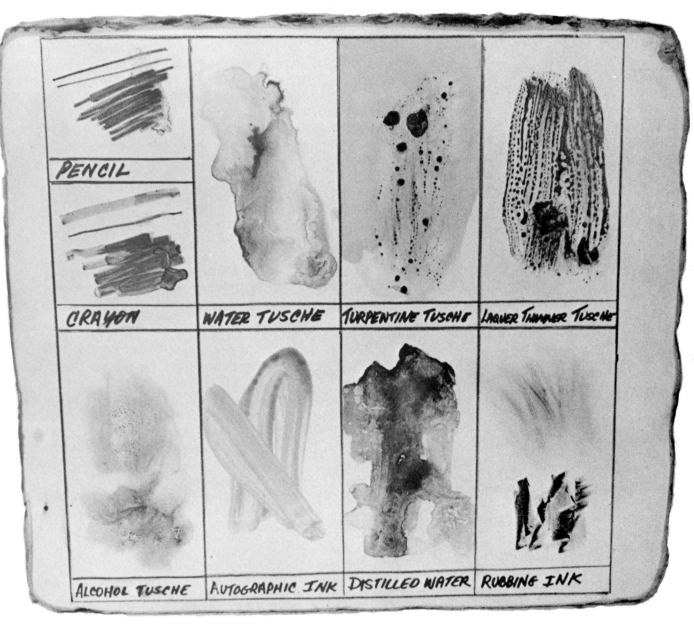

PENCIL	WATER TUSCHE	TURPENTINE TUSCHE	LAQUER THINNER TUSCHE
CRAYON			
ALCOHOL TUSCHE	AUTOGRAPHIC INK	DISTILLED WATER	RUBBING INK

3-1 Effects of drawing materials on a stone

STICK TUSCHE

Stick tusche (see Figure 3-2) is the solid form of tusche. By adding a small quantity of distilled water, the solid material may be liquefied. Rub the stick tusche evenly onto a saucer. Add distilled water and mix with a brush to produce the desired consistency.

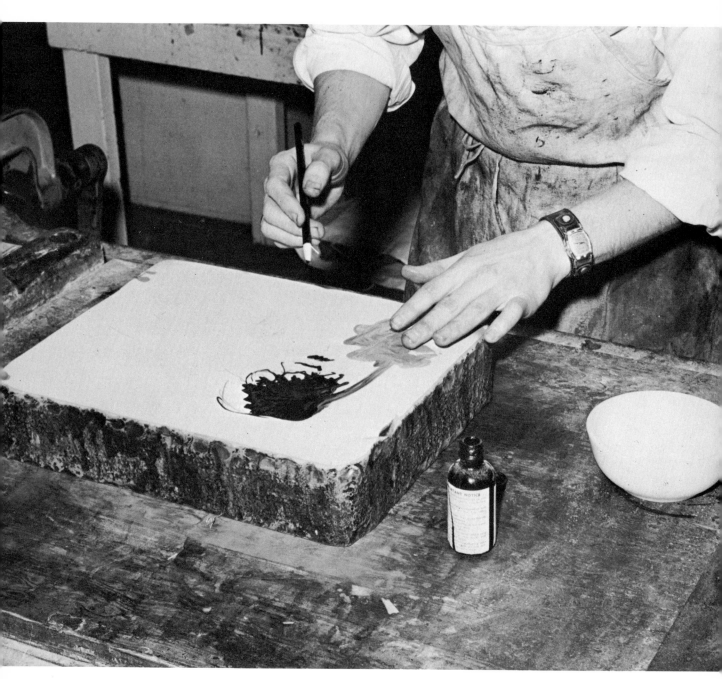

3-2 Drawing with tusche

AUTOGRAPHIC AND ZINCOGRAPHIC INKS

Autographic and zincographic inks will reproduce solid blacks in a single application because of their high grease content. There is no way to estimate the density of an autographic ink wash, since the liquid cannot be diluted in a controlled manner. Zincographic ink is less viscous and may be used in Rapidographs, ruling pens, etc.

RUBBING INK

Three grades of rubbing ink are available in stick form: hard, medium, and soft. By rubbing the stick onto a stocking or other soft material and transferring it to the plate or stone, various textural and tonal effects are realized. The amount of pressure applied to the plate or stone and the number of applications made determine the tonal intensity

CONTE CRAYONS

Markings made with a conté crayon will not print on a stone or plate because of the absence of grease in the composition of the crayon. Thus, conté crayons provide a quick and easy means of executing preliminary sketches, layouts, and registration. The crayons may be purchased in black, sepia, and white. *Note:* Conté crayon may act as a stopout when applied heavily.

GRAPHITE PENCILS

Drawings done with lead pencils are executed more successfully on plates than on stones. Drawings done in graphite, however, do not always reproduce completely.

GUM ARABIC

Gum arabic is an effective stopout material for sections of drawings. A dye such as methyl violet may be combined with the gum to give it color, making it more visible on the stone. Turpentine washes, litho crayons and pencils, etc. work well with this technique, since gum is water soluble.

PENS

Many ball-point pens, unlike other pens such as Rapidographs and ruling pens, produce a continuous line without constant refilling. When filled with zincographic ink, felt-tip pens draw broad, solid, flowing lines, although sometimes the ink must be heated to make it flow with ease.

BRUSHES

Several types of brushes, including bristle, sable, and acid brushes, will provide a wide range of textural effects. They can be used for stippling, the creation of washes, and drawing.

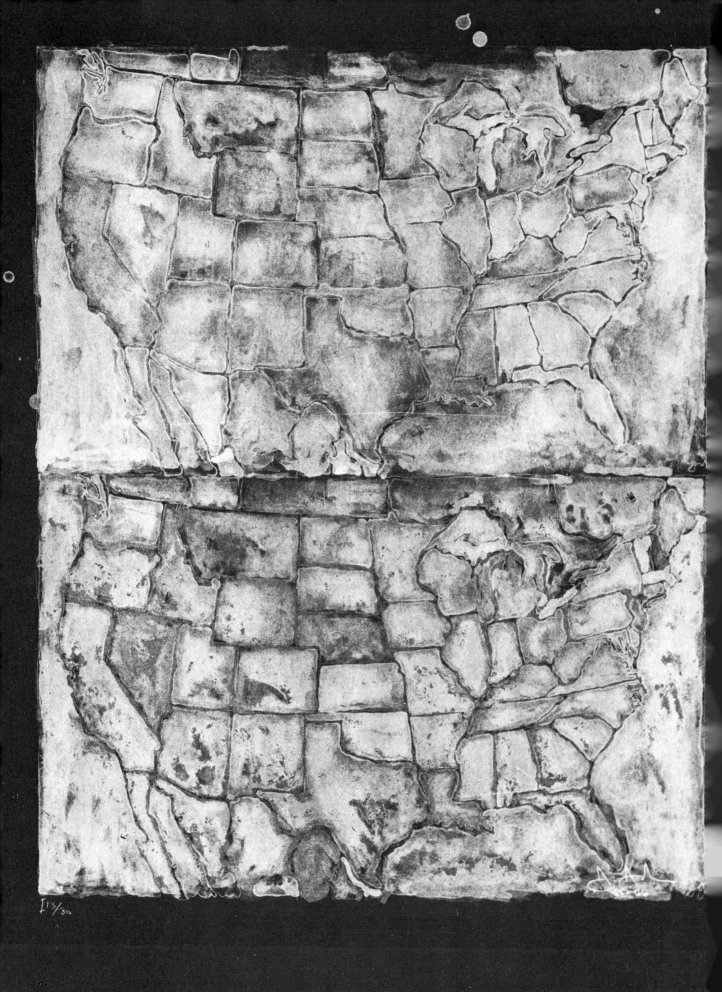

I¹³/₃₀

CARBON AND GRAPHITE PAPER

The use of carbon or graphite paper is an effective method of transferring a drawing to a plate or stone. Plates are particularly receptive to the grease in carbon or graphite paper and print the transfers easily, but graphite drawings transferred to stones do not always print.

ERASING MATERIALS

A scotch stone, pumice stone, razor blade, snake slip stone, rubber hone, or rubber eraser may be used for deletions on a litho stone or plate. Caution must be exercised with all these materials, since excessive abrasion will ruin the grain of a stone or plate. Rubber hones must be used with care on zinc plates for the same reason. Soft rubber erasers (Pink Pearl) may be used to remove small areas in a drawing.

DRAWING

You can draw directly on the lithographic stone or plate, but be sure to remember in this case that the final print will be a mirror image of the original drawing. This can be avoided by the use of transfer paper (as explained in Chapter 7) or by making the initial drawing on paper, tracing the outline of the image onto tracing paper, and then tracing from the back of the tracing paper onto the stone or plate. You can also draw directly on tracing paper, turn the drawing over, and trace onto the stone or plate.

Bleed Prints

A bleed print is a print in which the image runs off the paper on one or more sides. In the drawing, those areas that are to bleed should be extended beyond the planned size of the paper.

Registration

It is customary for the image to be placed on the paper uniformly throughout an edition. For this purpose, place register marks on the stone or plate and on the edition paper before beginning to print. (Methods of registration are described in Chapter 6.)

Opposite:
Two Maps I (1965-66), Jasper Johns. (Leo Castelli Gallery, New York. Photo, Rudolph Burckhardt)

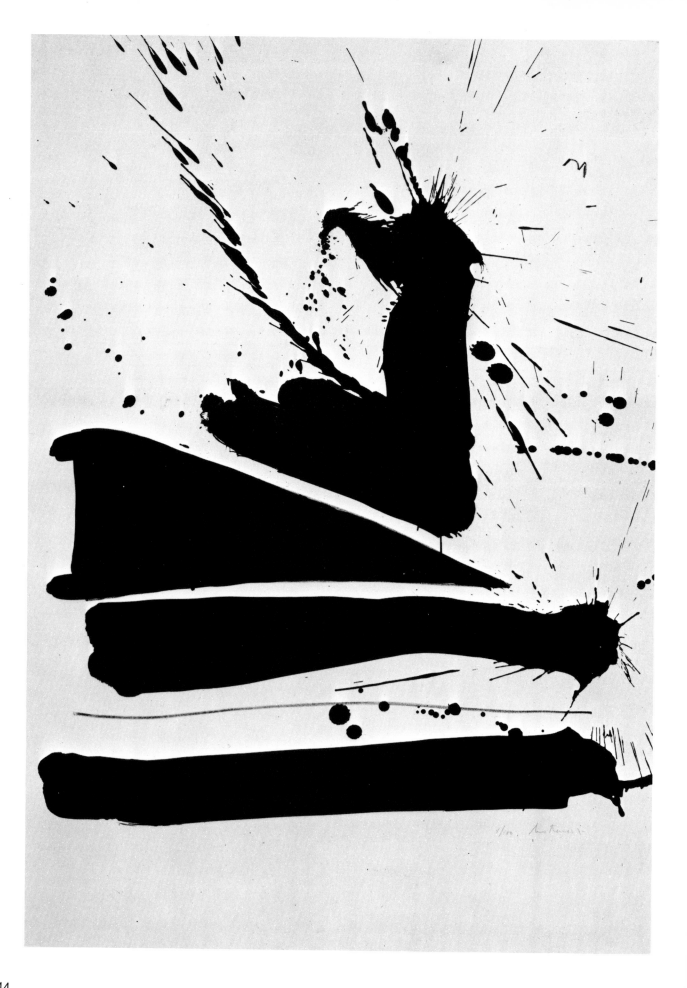

Preparing and Printing the Stone

Preparing the lithographic stone for printing involves several basic procedures—the rosin and talc process, etching, washout and rub up, rolling up, and proofing. Because these are so closely related in the actual execution, the supplies necessary for them are listed here together. Since the amount of each item needed is determined by the job at hand, it is advisable to keep large quantities of supplies near the printing area.

Orderly working habits are essential. A good edition of prints cannot be pulled unless the working area is scrupulously clean. All paper, including proofing paper, must be free of dirt or dust, which can adhere to the stone and mar its surface. Sponges and water should be clean and free from contamination. Check the blotter for dirt and grease, which may have rubbed off from the tympan, before beginning to print.

THE ROSIN AND TALC PROCESS

As explained in Chapter 2, the lithographic stone must be etched with gum arabic and nitric acid in order to retain the drawn image and desensitize the areas around it. Usually, multiple etching is required to stabilize the image for the full strength of the edition. The quantity of gum and acid in the etching solution varies according to the grade and size of the stone, the intensity of the image, and the technique employed in creating the drawing.

Before etching, however, the image must be protected from the action of the etching solution. This is done by applying first a coating of rosin, then one of talcum powder, to the stone. The rosin, which is acid resistant, protects the image; the talc absorbs the excess grease from the image, enabling the gum etch to adhere to the edges of the drawing.

Supplies

Rosin
Talcum powder
Absorbent cotton
Gum arabic (14 Baumé)
Nitric acid (70 percent)
Measuring cup (ounces)
4½″ brushes
Newsprint (an adequate quantity for the initial proofing)
6 yards of cheesecloth, torn into 1-yard sections
Roller (leather or composition)
Roller-scraping knife rounded at the sides for leather roller
1-pound can of black roll-up ink
Ink-spreading spatula
Turpentine or Lithotine
Soft, absorbent rags (a large quantity)
Triple Ink or liquid asphaltum
2 large pails of water
2 large photographic sponges
Blotters (larger in size than the proofing paper)
Tympan (slightly larger than the blotters)
1 can cup grease
Edition paper

Opposite:
Automatism B (1965), Robert Motherwell. (Collection, The Museum of Modern Art, New York. Gift of the artist)

Method

1. Using a large piece of soft, absorbent cotton, carefully dust powdered rosin lightly over the surface of the image (see Figure 4-1). Undue pressure will scratch and abrade the drawing.
2. Remove excess rosin from the image.
3. Buff the stone with talcum powder.

ETCHING

The Etching Solution

Because lithographic stones vary, it is difficult to compose a table that clearly and accurately describes the intensity of the solutions needed for etching. Nevertheless, the following table was devised by Ernest DeSoto (Director of Collector's Press, San Francisco) and revised by us. It is designed for hard yellow and medium light grey stones. Remember, however, that an artist's drawing technique on the stone also affects the etching. For example, overlays of multiple washes are deceptive and may require a slightly stronger etch. In addition, temperature and the grade of the stone may affect the etching. The student will learn how to adjust the etch by experience.

4-1 The rosin and talc process

ETCHING TABLE The drop system is calculated on the basis of 70-percent nitric acid.

	FIRST ETCH CYCLE		SECOND ETCH CYCLE		THIRD ETCH CYCLE	
	Solution	Time	Solution	Time	Solution	Time
1/10-STRENGTH WASHES AND LIGHT CRAYON #4 AND #5						
Korn's Liquid Tusche	1 ounce gum 4-6 drops acid	7 min.	1 ounce gum 5 drops acid	6 min.	1 ounce gum 3 drops acid	5 min.
Charbonnel Stick Tusche	1 ounce gum 5 drops acid	7 min.	1 ounce gum 4 drops acid	6 min.	1 ounce gum 2 drops acid	6 min.
La Favorite Stick Tusche	1 ounce gum 4 drops acid	7 min.	1 ounce gum 3 drops acid	6 min.	1 ounce gum 2 drops acid	6 min.
1/4-STRENGTH WASHES AND CRAYON #3						
Korn's Liquid Tusche	1 ounce gum 5-7 drops acid	7 min.	1 ounce gum 6 drops acid	6 min.	1 ounce gum 4 drops acid	5 min.
Charbonnel Stick Tusche	1 ounce gum 6 drops acid	7 min.	1 ounce gum 5 drops acid	6 min.	1 ounce gum 3 drops acid	6 min.
La Favorite Stick Tusche	1 ounce gum 5 drops acid	7 min.	1 ounce gum 4 drops acid	6 min.	1 ounce gum 3 drops acid	6 min.
1/3-STRENGTH WASHES AND CRAYONS #1 AND #2						
Korn's Liquid Tusche	1 ounce gum 6-8 drops acid	7 min.	1 ounce gum 7 drops acid	6 min.	1 ounce gum 5 drops acid	5 min.
Charbonnel Stick Tusche	1 ounce gum 7 drops acid	7 min.	1 ounce gum 6 drops acid	6 min.	1 ounce gum 4 drops acid	6 min.
La Favorite Stick Tusche	1 ounce gum 6 drops acid	7 min.	1 ounce gum 5 drops acid	6 min.	1 ounce gum 4 drops acid	6 min.
1/2-STRENGTH WASHES						
Korn's Liquid Tusche	1 ounce gum 8-10 drops acid	7 min.	1 ounce gum 8 drops acid	6 min.	1 ounce gum 7 drops acid	6 min.
Charbonnel Stick Tusche	1 ounce gum 7-9 drops acid	7 min.	1 ounce gum 7-8 drops acid	6 min.	1 ounce gum 7 drops acid	6 min.
La Favorite Stick Tusche	1 ounce gum 8 drops acid	10 min.	1 ounce gum 7 drops acid	8 min.	1 ounce gum 6 drops acid	7 min.
FULL-STRENGTH WASHES						
Korn's Liquid Tusche	1 ounce gum 13-14 drops acid	6 min.	1 ounce gum 10-11 drops acid	5 min.	1 ounce gum 7-8 drops acid	5 min.
Charbonnel Stick Tusche	1 ounce gum 12-13 drops acid	5 min.	1 ounce gum 10-11 drops acid	5 min.	1 ounce gum 6-7 drops acid	5 min.
La Favorite Stick Tusche	1 ounce gum 11-12 drops acid	5 min.	1 ounce gum 10-11 drops acid	5 min.	1 ounce gum 6-7 drops acid	5 min.

SOLID TONES

Tusche

Korn's Autographic Ink

Etch as for 1/10-strength washes

CRAYON WORK

Very light #5 litho crayon need only be etched with gum. The darker crayons should be etched according to the table above. Before starting the etching procedure it is necessary to cover the entire surface of the stone with gum arabic. Apply the various gum acid solutions over the gum. Allow the solutions to remain on the stone throughout the entire etch cycle.

FIRST ETCH

Method
1. After drying the image, rosin and talc the stone.
2. Using a 4½"-wide brush, coat the stone with undiluted gum arabic.
3. Depending on the grease content of the area in question, brush varying concentrations of the etching solution separately over the image. Start with the area containing the smallest grease content.
4. After waiting for the allotted time to pass, apply the next strength solution to the next greasiest area.
5. Continue spot-etching until the strongest etch has coated the areas with the greatest grease content.
6. After the allotted time has passed, blot off the excess etch solution with a sheet of newsprint; then wipe down and buff with cheesecloth to a smooth and even layer (see Figure 4-2). *Note:* If at the end of the etch cycle the solution has dried completely on any part of the stone, pour gum over the whole surface. This will dissolve the parts that have dried, enabling you to wipe down the stone evenly. The gum-etch coating *must* be wiped down evenly and smoothly until it appears dry.
7. After wiping down the stone, leave it for two hours before washing it out.

4-2 Wiping down the stone

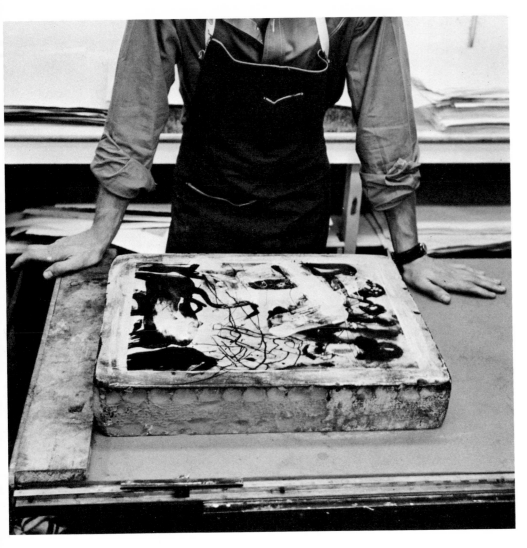

4-3 Blocking the stone on the press

POSITIONING THE STONE ON THE PRESS

Before beginning the washout and rub up of the stone, it should be positioned on the press.

Method
1. Transfer the stone to the press bed. Be sure the stone is situated on a rubber or linoleum mat that will absorb uneven pressure and help prevent breakage of the stone.
2. Place the stone in the approximate center of the press bed, securing it from the rear of the stone to the rear of the press bed, as shown in Figure 4-3.
3. Choose the proper scraper bar.
4. Prepare roll-up black ink and, if necessary, mix in additives for the specific job (see Chapter 9).
5. Prepare the roller. After scraping the roller, roll off all excess ink. Clean the slab. With a stiff spatula (see Figure 4-4), spread a thin band of ink, longer than the width of the roller, across the inking slab to minimize ink build-up at the edges of the roller. Roll and evenly distribute the band of ink over the surface of the slab. Twist the roller slightly every few strokes. This action brings different sections of the roller into contact with the ink, producing an even layer of ink on the slab. Check the surface for particles of dirt, etc.

4-4

Ink-spreading spatula

49

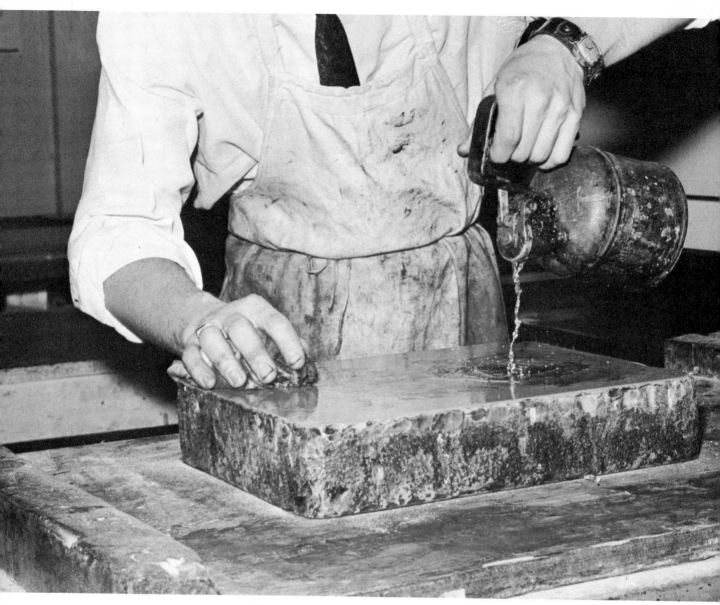

4-5 Washing out with Lithotine

WASHOUT AND RUB UP

Method
1. Pour a small amount of turpentine or Lithotine over the drawn areas of the stone. With a clean, bone-dry rag, remove (wash out) the drawing through the gum-etch coating (see Figure 4-5). Be sure to rub very softly, slowly removing the image. Rubbing hard may abrade and break down the gum coating.
2. Rub up the stone with Triple Ink by rubbing the entire washed out surface evenly and smoothly (see Figure 4-6). *Note:* If Triple Ink is not available, substitute liquid asphaltum or a combination of turpentine and the printing ink for the edition. When using asphaltum, follow the same procedure as for Triple Ink. For the ink-turpentine mixture, place a small amount of ink on a rag dampened with turpentine. Make sure there is sufficient ink to protect the image; if too much turpentine is added to the printing ink, the coating will be too thin and the process must be repeated.
3. Fan dry (see Figure 4-7).
4. Wash off the stone with a rag and water (see Figure 4-8).
5. Sponge the surface with a damp sponge and proceed to roll up.

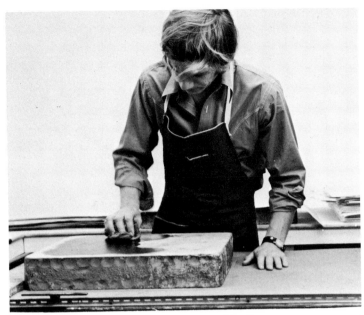

4-6 Rubbing up

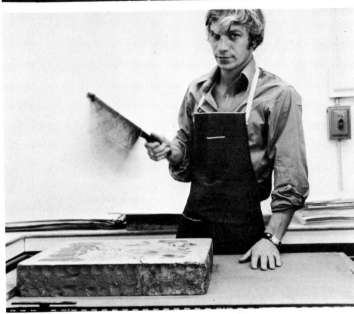

4-7 Fan drying

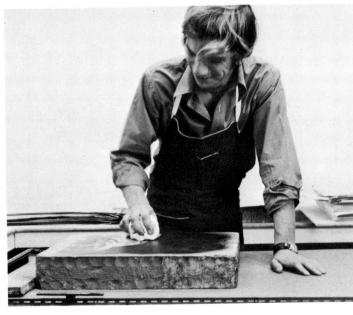

4-8 Washing off rubbing ink

ROLL UP

The size of the image determines the size of the roller. Ideally, a roller should be larger than the image to prevent the roller marks from forming across the image. However, if this is not possible, "feathering," the rolling procedure illustrated in Figure 4-9, will prevent the appearance of roller marks and help the uniform inking of the surface.

Method
1. Start to roll over the stone, following the pattern shown in Figure 4-10. *Note:* Do not use too much water in dampening the stone. The water should be spread in a thin, even layer over the entire surface. Too much water may cause scumming, water marks on the final print, and burning of the image. In the beginning, do not ink the roller too heavily—ink build-up should be gradual. Some areas of an image may require re-inking of the roller halfway through the cycle.
2. Keep dampening the stone and rolling until the surface is evenly and sufficiently inked. It is very difficult for the inexperienced eye to judge what a well-inked surface looks like. If an even build-up does not occur, proofing is necessary. This will increase the receptivity of the stone to ink, so the second etch can take place.

4-9

"Feathering" rolling pattern

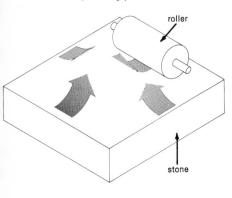

4-10

Rolling pattern

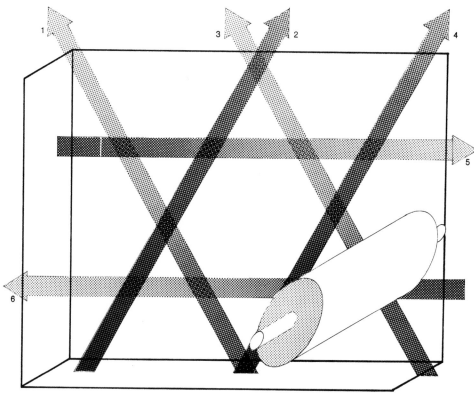

(the numbers indicate the rolling sequence)

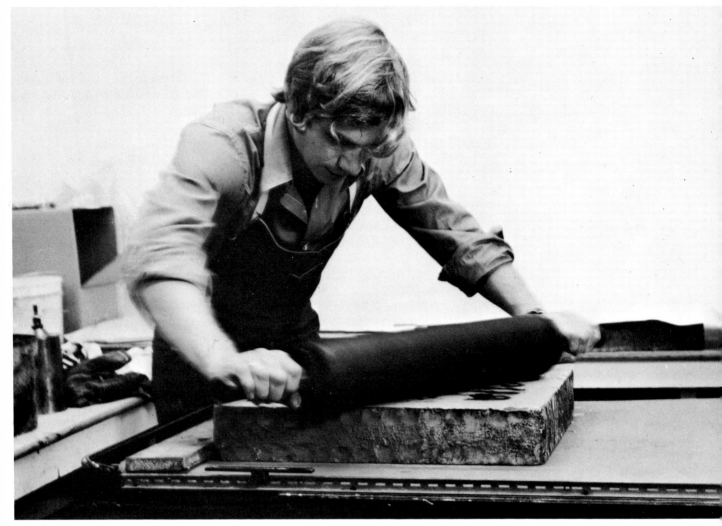

4-11 Rolling up image

ETCHING AND ROLL UP FOR VERY DELICATE DRAWINGS

It is recommended that a slightly different procedure be followed for etching and rolling up very fragile drawings such as light crayon work and very delicate washes, which are often lost in the usual etching procedure. Two solutions must be prepared.

Method
1. Rosin and talc the stone.
2. Etch the stone.
3. Dry down the etch with cheesecloth.
4. Allow the stone to remain under the etch for approximately twenty minutes.
5. Wash out the image with turpentine.
6. Wet one sponge with the gum-water solution and a second sponge with the ink-turpentine solution. With a sponge in each hand, charge the stone as evenly as possible with ink and gum. Work the ink deeply into the image, which will be prevented from spreading by the gum solution. Keep a large quantity of gum solution handy, and change it when it gets dirty.
7. Continue as in step 6 until the entire image has been charged and appears darker than the original drawing. Otherwise the delicate areas will not have enough ink.
8. Wash off the remaining gum and ink from the surface of the stone.
9. Dry the stone.

Ink-Turpentine Solution

50 percent roll-up black
50 percent Triple Ink
Saturate this mixture with turpentine.

Gum-Water Solution

50 percent gum arabic
50 percent water

SECOND ETCH AND PROOFING

Method

1. Rosin and talc.
2. See etching table for proper solution and etch the stone. *Note:* Be sure to coat the stone with undiluted gum arabic before applying the second etch.
3. Dry down the second etch. The stone should be left undisturbed for at least one hour before washing it out.
4. Wash out and rub up.
5. Roll up. Only when the image is satisfactorily inked should paper be placed on the surface of the stone. As a precautionary step, set a sheet of newsprint on top of the paper to keep the back of the print clean. (If a bleed is desired, the newsprint will absorb ink extending beyond the printing paper and must therefore be changed each time a print is made.)
6. Put a blotter on top of the newsprint, and the tympan on top of the blotter (see Figure 4-12). Slide the press bed lining up the scraper bar with the edge of the stone, and register the press bed with the side of the press by attaching tape or marking both surfaces. This will eliminate the need for constantly re-aligning the scraper bar with the edge of the stone.
7. Pull down the pressure lever and regulate the pressure screw (see Figure 4-13). Slight adjustments in pressure may be required to obtain a sharp, clear impression.
8. Spread grease evenly on the tympan in front of the scraper bar (see Figures 4-14 and 4-15).
9. Proceed to proof. After a number of prints are pulled, the printer should be able to estimate the direction and number of rolls needed to bring up the image, how often ink should be added to the slab, the number of times the stone must be sponged, and, in general, develop a precise and systematic

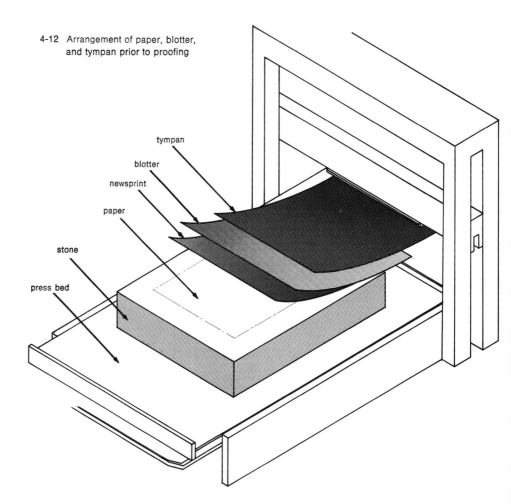

4-12 Arrangement of paper, blotter, and tympan prior to proofing

tympan

blotter

newsprint

paper

stone

press bed

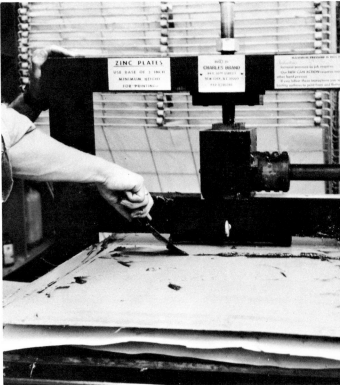

4-13 Adjusting press pressure

4-14 Spreading grease on the tympan

approach to pulling prints. *Note:* Should difficulties arise, check whether the ink is too stiff, pressure is insufficient, or the image has been burned. To remedy the first condition, scrape the roller, clean the ink slab, and soften the remaining ink by adding a small amount of fresh ink to the mixture; remove old ink by taking a proof on newsprint, and proceed to roll. In the second case, simply increase the pressure. Be careful, however, since excessive pressure may cause the image to fill in gradually or may break the stone or the press. If the image has been burned, counteretch the stone (see below, this chapter) and redraw the burned areas.

10. Proof until a good print is pulled.
11. Place registration marks on stone and paper by T registration (see Chapter 6) to ensure uniform placement of image throughout edition.
12. Roll up the image as if for pulling another proof.
13. Fan dry and proceed to third etch.

4-15 Arrangement of paper

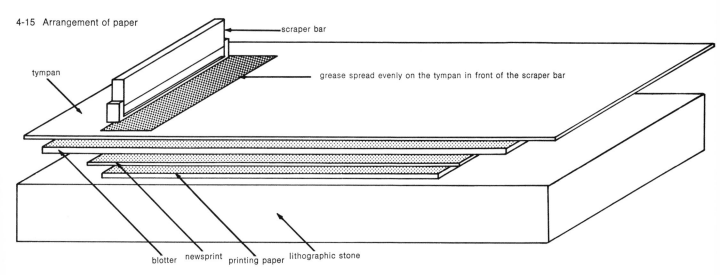

scraper bar

tympan

grease spread evenly on the tympan in front of the scraper bar

blotter newsprint printing paper lithographic stone

THIRD ETCH AND PRINTING

Method
1. Rosin and talc.
2. See etching table for proper solution and etch the stone. *Note:* Be sure to coat the stone with undiluted gum arabic before applying the third etch.
3. Dry down and leave stone for one hour.
4. Wash out and rub up.
5. Roll up and pull proofs.
6. Begin printing. *Note:* No further etching is required unless the edition is not completed. In this case, a mild overall etch of 5 or 6 drops acid per ounce of gum will prevent the image from darkening from one day to the next.

DRYING

After printing, place the impressions on a clean surface or a drying rack (Figure 4-16) and cover each with a sheet of newsprint to prevent one print from transferring ink to the back of the next and to keep the prints clean. After a few days, depending on the amount of drier in the ink, the color of the ink, and the room temperature, the prints should be dry. As soon as they are dry to the touch, remove the newsprint slip sheets, since they have a high acid content and may discolor the lithographs.

4-16 Print-drying rack

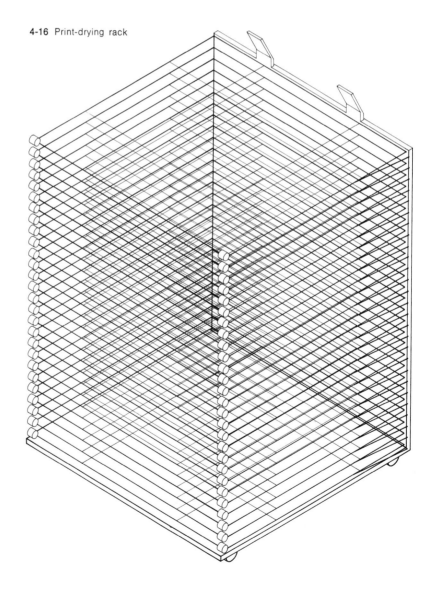

PRINTING ON DAMPENED PAPER

It is often desirable to dampen the paper before printing, as shown in Figure 4-17. (Since paper tends to stretch, the advantages of this procedure are limited to images that do not require precise registration.) This method will allow you to use less ink and less pressure, thereby minimizing the stone's potential to fill. Delicate washes which often do not print when you run the paper dry will usually come up when you use this procedure. If you are used to printing dry, you must be careful, since there is a tendency for the stone to print slightly darker when the paper is wet.

Method

1. Sponge each sheet of paper on one side only; then stack on top of the polyethylene sheet.
2. Wrap the polyethylene around the entire pile of paper.
3. Leave the polyethylene-covered stack of paper overnight. This will distribute the moisture evenly throughout the entire stack.
4. The following morning, remove each sheet as you are about to print.
5. After printing, place each sheet between blotters and cover the pile with a large board and heavy weights.

Supplies

Clean bucket
Clean sponges
Polyethylene sheet (large enough to wrap entirely around the paper to be dampened)
Edition paper (*Note:* Use of Arches paper will minimize curling. Other papers tend to warp badly.)

4-17 Dampening paper

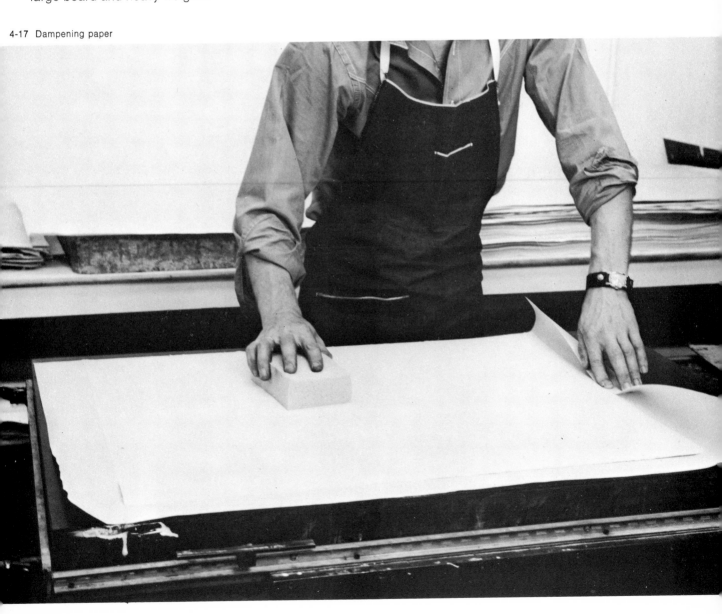

FOUNTAIN SOLUTIONS

Harris Non-Tox Fountain Solution and Imperial Fountain Solution

30 cc. fountain solution
30 cc. gum arabic
1 gallon water
Check the solution with litmus paper. The pH value should be approximately 5.
or
commercial fountain solution
or
¼ ounce ammonium phosphate
13 ounces gum arabic
1 gallon water

A fountain solution may be used in conjunction with water to keep the stone clean and free of scum in printing. Take great care when using this solution, because it behaves like a regular etch. Excessive use will cause breakdown of the image and counteretching of the negative areas, which will cause more scumming. Never sponge the fountain solution onto a stone that has not previously been inked, or the image will be burned. Be careful not to confuse the sponge used for water with the sponge used for the fountain solution.

There are many commercial brands of fountain solution. Ordinarily they are marketed in concentrated form and must be diluted with water.

CORRECTIONS AND DELETIONS

Corrections and deletions on litho stones may be made by abrasion or caustic removal (Figures 4-18 and 4-19). Caustic removal can also produce tonal gradations and various textures.

Abrasion

Supplies

Snake slip stone, pumice stone, or razor blades
Sponge

Method
Dampen the area to be removed before rubbing with the abrasive, and clean the surface from time to time with a damp sponge to check the amount of abrasion. The stone must be re-etched and the gum coating restored after abrasion.

Caustic Removal

Supplies

Gum arabic
Nitric acid

Method
Brush or splash a strong acid-gum solution over the areas to be removed or corrected. The strength of the solution and the length of time that it remains on the surface of the stone will determine its effectiveness. *Note:* This technique should not be practiced by an inexperienced lithographer. The areas burned with the solution will usually appear much lighter. And because this technique alters or destroys the grain structure, it is difficult to pull a consistent edition.

4-18 Abrasion

4-19 Caustic removal

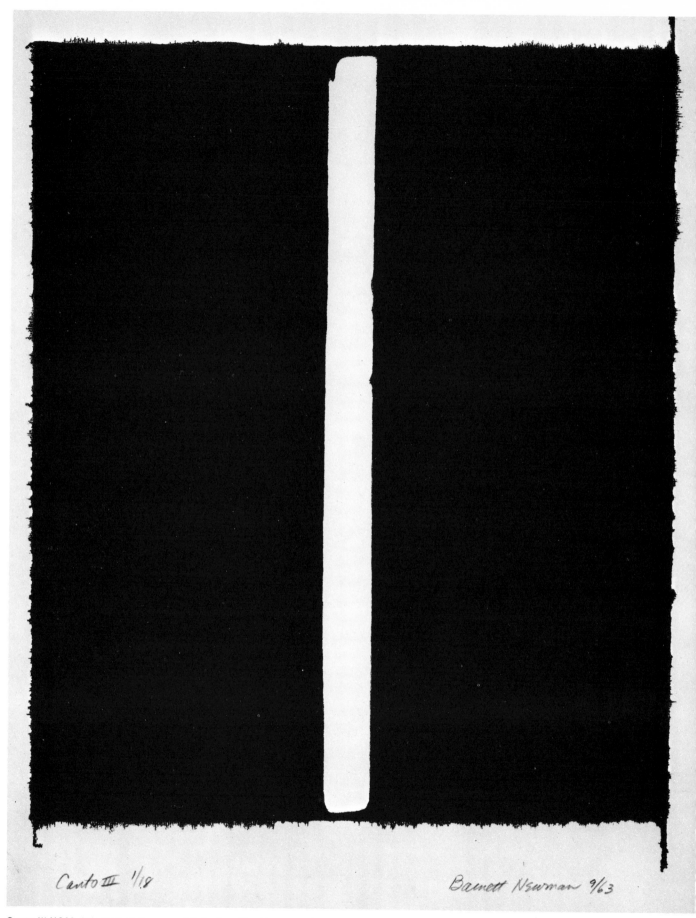

Canto III (1963-64), Barnett Newman. (Collection, The Museum of Modern Art, New York. Celeste and Armand Bartos Fund)

ADDITIONS AND COUNTERETCHING

A stone must be resensitized (counteretched) in order to add to an etched drawing. The following solution—or white vinegar—may be used.

Method
1. Roll up the stone.
2. Rosin and talc.
3. Paint or pour the counteretch solution over the area to be resensitized. Allow the solution to remain for two minutes.
4. Thoroughly wash off the counteretch with water.
5. Allow to dry.
6. Add or redraw.
7. Rosin and talc.
8. Cover the entire surface with undiluted gum arabic and spot-etch (etch the redrawn areas). *Note:* Be sure to wash out the entire stone, even though you are re-etching only the redrawn areas.

Counteretch Solution

9 parts water
1 part glacial acetic acid

SIGNING AND NUMBERING THE EDITION

Throughout history, artists have dated, signed, numbered, and titled their prints (see Figure 4-20). With a few exceptions, the following list of terms represents the expressions in common usage today.

4-20 Numbering the edition

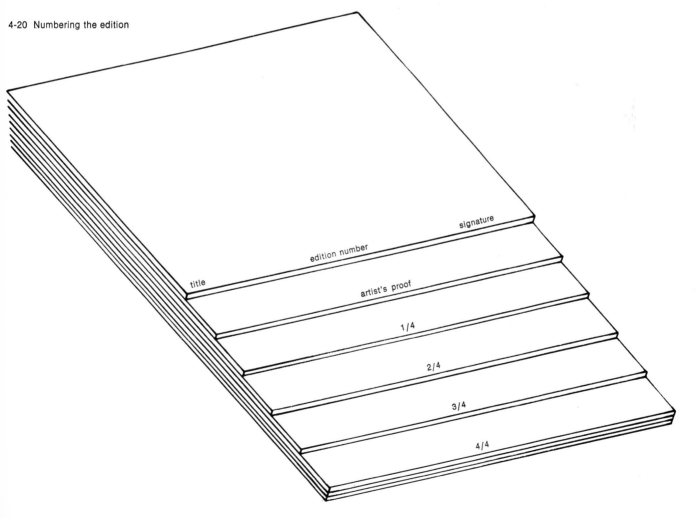

Bon à Tirer

According to tradition, when an artist works with an artisan-printer, the latter is entitled to one print from the edition. The first lithograph the artist approves is marked *Bon à Tirer,* and usually is presented to the printer as authorization to begin the run of the edition. It also represents the standard of quality to which the edition must conform. The English term for Bon à Tirer is Printer's Proof.

Artist's Proof

An artist often keeps a number of impressions from an edition; these are marked *Artist's Proof.* Ordinarily, the quality of these prints does not differ from the rest of the edition. However, in the course of printing, slight variations that please the artist may develop in an image. These variant impressions are also inscribed Artist's Proof. The number of Artist's Proofs is indicated on any literature released about an edition.

State

Occasionally a series of prints is created from an initial image by adding to the image or deleting from it to produce a new print. The first print edition is labeled *State I.* Each successive elaboration is marked with a higher roman numeral; the second group of prints is marked State II, and so on. Thus, when all the states of the print are viewed together, it is possible to understand an artist's thought processes and creative development.

Standard Numbering

As soon as the edition is set, the numbering is indicated as a fraction. The top number designates the numerical sequence in which the prints were signed. The bottom number of the fraction denotes the total impressions in the edition.

Printer's Proof

There may be more than one printer's proof if the artist desires. It is protocol to give the printer a printer's proof. Sometimes the artist may wish to give others in the workshop who participated in the production of his edition a "PP." Then they are numbered PP1, PP2, etc.

Presentation Proof

Prints that are signed by the artist to a friend or collaborator are equal in quality to those in the edition.

Cancellation Proof

After the edition has been pulled the artist may wish to deface the image and print it. This is done to clearly show that it is impossible to pull any more impressions from the stone.

Zinc and Aluminum Plate Lithography

Metal lithography plates were developed because of the high cost, unwieldy size and weight, and inefficiency of the lithographic stone. Both zinc and aluminum plates have been in use for nearly fifty years, and they have entirely replaced the litho stone in commercial work. Metal plates differ from litho stones in being lightweight and easily transported; they can be used on rotary offset presses for faster production, and they have unique surfaces on which exciting wash effects can be produced.

PROPERTIES OF ZINC AND ALUMINUM PLATES

Zinc plates are a grey metal alloy of 10 to 12 percent cadmium, 6 to 8 percent lead, and a minute quantity of iron. Zinc is oleophilic (receptive to grease and water-repellent). It is affected by nitric, hydrochloric, and sulfuric acid, and oxidizes rapidly. Zinc plates may be used repeatedly, however, provided that they have been regrained. Number 10 gauge metal is the minimum gauge that should be used.

Aluminum plates have replaced zinc plates in commercial lithography, so they are easily acquired by the artist. They are whitish grey in color, and thinner, softer, and two and a half times lighter than zinc. They are also cheaper—the price of a new aluminum plate is almost less than the cost of regraining a zinc plate. Most important, the metal is hydrophilic (receptive to water and grease-repellent), which means that it stabilizes easily and prints cleanly. The plates are attacked by hydrochloric and sulfuric acid and alkalies, but are resistant to nitric acid.

The optimum thickness for aluminum plates is .012", since thicker plates will curl, and thinner ones may crease or buckle. Do not use photo-aluminum plates: their grain is too fine for hand lithographic work.

BEHAVIOR OF ZINC AND ALUMINUM PLATES

The creation of oleomanganate of lime on the lithographic stone is a steady and continuous process, resulting from the chemical interaction of acid and calcium carbonate. The penetration of the oleomanganate of lime into the pores of the stone establishes a stable and deep grease reservoir. This is not the case with metal plates, although there is slight penetration into the metal. The grease remains on the surface of the plate, tightly adhering to the irregular grain structure.

Because zinc is oleophilic and aluminum is hydrophilic, each metal requires its own special etch. Nevertheless, the basic effect of the etch remains the same in both cases. First, an insoluble adsorption gum film is deposited onto the plate, desensitizing the non-printing areas and facilitating the attraction of water within these areas. Secondly, the grease of the drawn image combines with the etch and the metal plate itself, forming the grease reservoir.

GRAINING METAL PLATES

The grain on metal plates enables them to retain water in the non-printing areas and to hold the drawing in the printing areas, and it gives the gum coating a better anchor on the metal. The type of grain influences all of these factors.

The most diversified zinc surface capable of handling directly drawn images has a grain of 220. A finer grain forces the ink deposited on the peaks of the grain closer together, which may cause clogging and filling in of the image; a coarser grain causes certain types of drawings—large, flat areas, for instance—to push out at the edges under pressure. The grain of aluminum plates used in hand lithography is designated deep-etch ball-grained, and a grain of 620 is recommended.

Metal plates are generally grained outside the studio. The grain obtained is determined by the abrasive and the type and size of marble used in the process (the marbles serve the same function as the levigator in graining a stone). Pumice, ground glass, carborundum, flint, and sand are commonly used abrasives; the marbles are usually wood, glass, porcelain, or steel.

Before a plate is regrained, the old image is removed with a solvent. Then the plate is soaked in lye and washed with diluted oxalic acid to eliminate all remaining traces of grease or hardened albumen (used in photolithography).

Plates regrained in a machine should be uniform in depth, have an even surface, and be free of scratches. After regraining, plates should be immediately washed to remove all caustic material, then rapidly dried to prevent oxidation. The surface should have a uniform color and be very clean.

STORAGE OF METAL PLATES

Store plates in a rack situated in a cool, dry area. Place them face to face and interleave them with very thin tissue or glassine (see Figures 5-1 and 5-2). Do not use newsprint slip sheets, since they absorb water and contain chemicals which oxidize the metallic surfaces.

COUNTERETCHING

Only when a plate is absolutely clean may the artist begin drawing directly onto the prepared surface. Plates that have acquired dirt or spots from oxidation or mishandling must be counteretched. Counteretching is also necessary to resensitize a drawing for additional work on the design. The method of counteretching zinc and aluminum plates is the same, but the solutions used are different.

5-1, 5-2 Storage of metal plates

Zinc Counteretch Solution

1 ounce hydrochloric acid
1 gallon water

or

10 drops nitric acid
1 gallon water
Saturate this mixture with alum.

or

2 ounces Harris Commercial Counteretch
1 gallon water

Aluminum Counteretch Solution

9 ounces ammonium bichromate (Photo Grade)
9 gallon water
1 ounce hydrofluoric acid

or

Commercial Plate Counteretch (use as directed by manufacturer)

Method

1. Flood the plate with water and rub with a wad of cotton.
2. Rinse plate with water and drain off excess water.
3. Flood the plate with counteretch. Tilt the plate back and forth to cover it with the solution until the plate changes color.
4. Rinse with water.
5. Drain off excess water.
6. Repeat steps 3, 4, and 5.
7. Blot and fan dry as quickly as possible to avoid re-oxidation.
8. Begin drawing.

Figures 5-3, 5-4, and 5-5 graphically demonstrate that the only difference between the effects achieved on a stone or zinc or aluminum plate is in the tusche water wash on zinc. This wash, called *peau de crapeau* ("toadskin"), is caused by oxidation and the rate of evaporation of the water on the surface of the plate. Artists who desire this effect will inevitably work on zinc plates, although a similar effect may be obtained on aluminum plates by using salt water instead of tap or distilled water mixed with the tusche.

5-4 Effect of drawing materials on a zinc plate

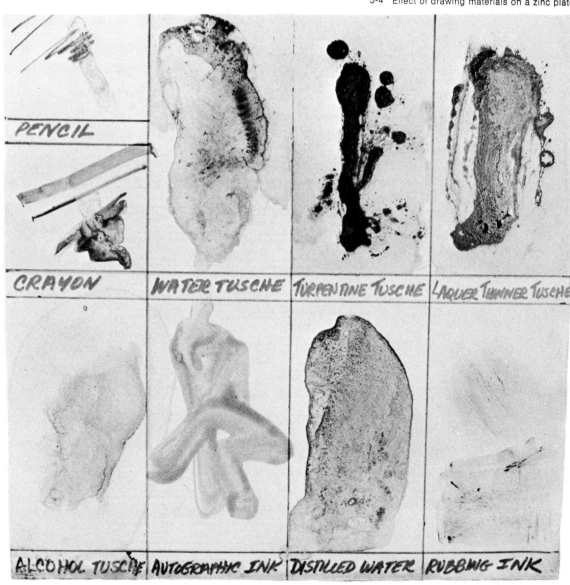

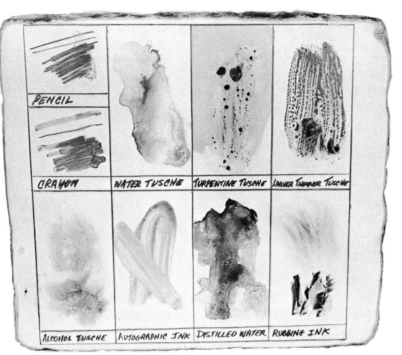

5-3 Effect of drawing materials on a litho stone

5-5 Effect of drawing materials on an aluminum plate

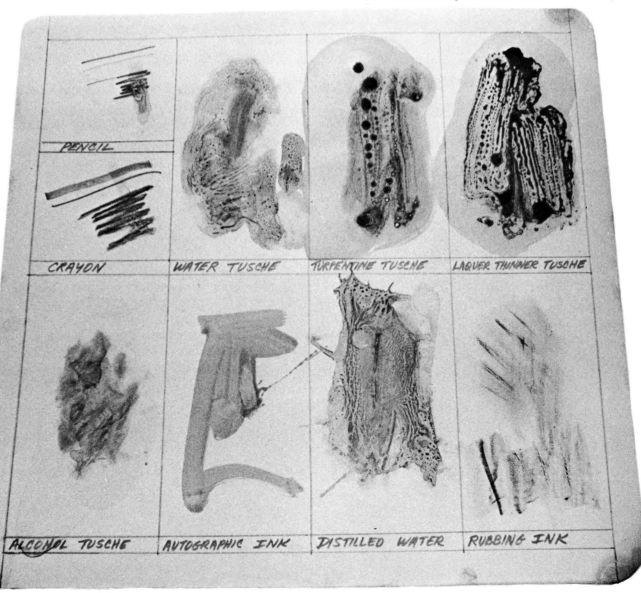

POSITIONING THE PLATE ON THE PRESS

For convenience, metal plates can be etched on the press bed. To secure the plate, run a dampened sponge across the bed, place the plate over the dampened area, and move it slightly to achieve suction. Before beginning to etch, mop up excess water around the plate.

ETCHING ZINC PLATES

The use of prepared commercial etches on zinc (and aluminum) plates is strongly recommended. If the commercial solutions are not available, however, the alternative solution may be used.

Etching Solution (First Etch)

50 percent Hanco Cellulose Gum Etch (Acidified) MS #571
50 percent gum arabic

or

16 ounces isopropyl alcohol
5½ ounces cellulose gum
3½ quarts water
1½ ounces magnesium nitrate crystals
1 ounce phosphoric acid
Dilute this solution with 50 percent gum arabic.

Stir for one minute. Check the solution with litmus paper. The pH value should be 2.9 to 3.3.

Method
1. Talc the image.
2. Thoroughly mix the etching solution, using a 3″ brush. Paint the entire surface of the plate with the etch as rapidly as possible. Keep the etch moving at all times, first brushing horizontally, then vertically, for two to two and a half minutes, depending on the density of the image. Very light washes require less etching time. *Note:* Scumming and streaking may occur if the etch has not been brushed on evenly.
3. Wipe down plate evenly with cheesecloth until it appears dry.
4. Allow plate to stand for at least five minutes.
5. Wash out the image with turpentine or Lithotine through the dry gum-etch coating until the entire drawn image is removed.
6. While the plate is still damp with turpentine, thinly and evenly cover the entire surface of the washed out image with Triple Ink or asphaltum.
7. Fan dry.
8. Wash the entire surface of the plate with a damp cloth.
9. With a damp sponge, wipe the entire plate and proceed to roll up. When the image is completely rolled up, continue with the second etch.

Etching Solution (Second Etch)

75 percent Hanco Cellulose Gum Etch (Acidified) MS #571 or the alternate solution
25 percent gum arabic

Method
1. Dry the plate.
2. Talc the image.
3. Make all additions or deletions.
4. Thoroughly mix the etching solution and paint the entire surface of the plate. Keep the etch moving rapidly horizontally and vertically for approximately three minutes.
5. Wipe down plate evenly with cheesecloth until it appears dry.
6. Allow plate to stand for at least five minutes before printing or storing plate.

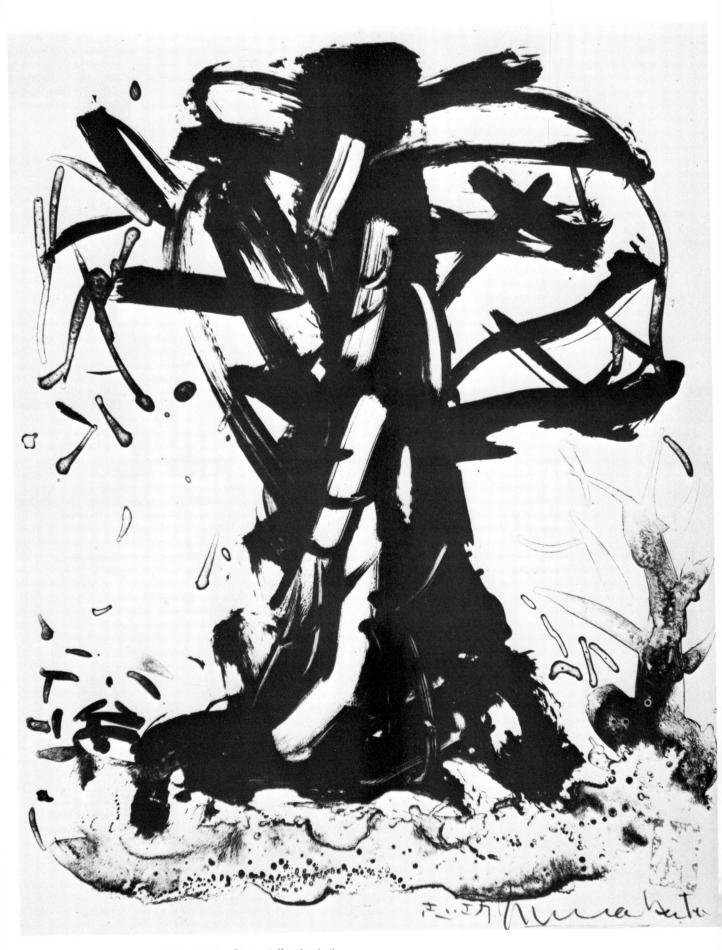

Tree, Munakata. (Courtesy of Irwin Hollander. Photo, Jeffrey Loubet)

ALUMINUM PLATE ETCHING AND LACQUERING PROCEDURE

Note: Pre-mix the stock solution by adding phosphoric acid to gum arabic to a pH value of 2.5. Using litmus paper always check to make sure that the pH of the stock solution has remained constant.

If your aluminum plates are clean and fairly new, there is usually no need to counter-etch them. Counter-etching changes the grain structure, so it is advisable to counter-etch only when absolutely necessary.

Supplies

Lith-Kem-Ko Lacquer C
Lith-Kem-Ko Lacquer C Solvent
Hanco Tannic Acid Plate Etch
Webril wipes
Kim Wipes or soft rags
Stock solution (etch) pH 2.5 gum arabic
 and phosphoric acid
3-inch wide brush
Narrower brushes for applying etches
Gum arabic
Cheesecloth
Litmus paper

Method

1. Check the etch table to determine the strengths of the crayon or washes and pre-mix the desired etches to be used. If there are solids and medium washes using solvent tusche, then you must pre-mix three different etch solutions in enough quantity to cover these areas to be etched.
2. Talc the image. Use cotton and buff the image vigorously.

 Caution: Do not rosin the image. Rosin is an abrasive and will scratch the soft aluminum.

3. Pour a puddle of gum arabic into the center of the plate and immediately spread the gum over the entire plate and image evenly with your 3-inch wide brush.
4. Using a smaller brush, spot-etch by carefully dribbling the pre-mixed etch solutions over their designated areas. Start with the darker areas.

 Note: The etch will continue to work until it has been buffed dry, so take this into consideration when you start to time your etches.

5. Buff dry with cheesecloth.
6. Allow to dry for at least 15 minutes.
7. Using a soft rag, wash out the drawing material with turpentine and rub-up with triple-ink.
8. Dry.
9. Roll-up the image using stiff ink. Continue to roll until the drawing is approximately 10-percent darker than when you drew it. Look at the ink layer and touch it to make sure that there is an even layer over the image area.
10. Dry.
11. Talc.
12. Using a wet sponge, clean the image and remove all unwanted spots or areas with a glass brush, rubber hone.
13. Dry the plate.
14. Gum the plate.
15. Using cheesecloth dry down the gum film. Let stand at least 10 minutes.
16. Wash-out the drawing with turpentine or lithotine.

 Caution: Make sure that no water touches the surface of the plate or image at this time.

17. Using Webril Wipes or soft absorbent rags continue to clean the image with Lacquer C Solvent. Continue until all black grease areas are spotless.
18. Let dry for approximately 10 minutes.
19. Pour a pool of Lacquer C onto the middle of the plate and using Kim-Wipes or a soft rag in circular motion wipe down to a thin, even film. Polish well.
20. Dry for at least 10 minutes.
21. Rub on triple ink or asphaltum over the blue Lacquer C using circular motions. Wipe until there is a thin even coat.
22. Dry.
23. With a water-soaked rag wipe the entire surface of the plate until you see the excess Lacquer C being removed, then sponge and roll rapidly removing all excess Lacquer C.
24. Roll-up the image as if ready to proof.

25. Dry the plate.
26. Talc the image.
27. Add 1 tablespoon of magnesium carbonate to an ounce of gum arabic and sponge lightly over the entire plate to clean it. (If the plate is spotless it is not necessary to do this procedure.) Again, remove any unwanted areas, this time first with Lacquer C Solvent and then with a rubber hone if necessary.
28. Wipe the entire plate clean with water.
29. Dry.
30. *Second etch:* Pour a mixture of 2 ounces of Hanco Tannic Acid Etch and 2 ounces of gum arabic over the image and proceed to sponge over the entire plate for approximately 1 minute to 1½ minutes. Blot off the excess with news-print and buff down dry with cheesecloth.
31. Dry for approximately 15 minutes.
32. Wash off the tannic etch.
33. Dry.
34. Gum.
35. Buff down dry with cheesecloth.
36. Dry for 10 minutes.
37. Wash-out with turpentine or lithotine, rub-up with triple-ink or asphaltum and proceed to print.

ETCH TABLE FOR ALUMINUM PLATES

Type of Drawing	Proportion of Etch	Duration
Light crayon, #5, #4	75% gum arabic 25% stock solution	30—45 sec
Medium crayon #4, #3	50% gum arabic 50% stock solution	30—45 sec
Dark crayon #1, #0	100% stock solution	1 min
Rubbing crayon	25% gum arabic 75% stock solution	45 sec ½—1 min
Full-strength solids and lines (tusche)	75% gum arabic 25% stock solution	30—45 sec
Light washes (water tusche)	50% gum arabic 50% stock solution	30—45 sec
Light washes (solvent tusche)	75% gum arabic 25% stock solution	30—45 sec
Medium washes (water tusche)	50% gum arabic 50% stock solution	45—60 sec
Medium washes (solvent tusche)	25% gum arabic 75% stock solution	1—2 min
Dark washes (water tusche)	100% stock solution	1—2 min
Dark washes (solvent tusche)	100% stock solution or 100% pH 2.0	1—2 min 30—45 sec

(Etch table from *Tamarind Book of Lithography: Art & Techniques,* by Garo Z. Antreasian with Clinton Adams, reprinted by permission of Harry N. Abrams, Inc., New York)

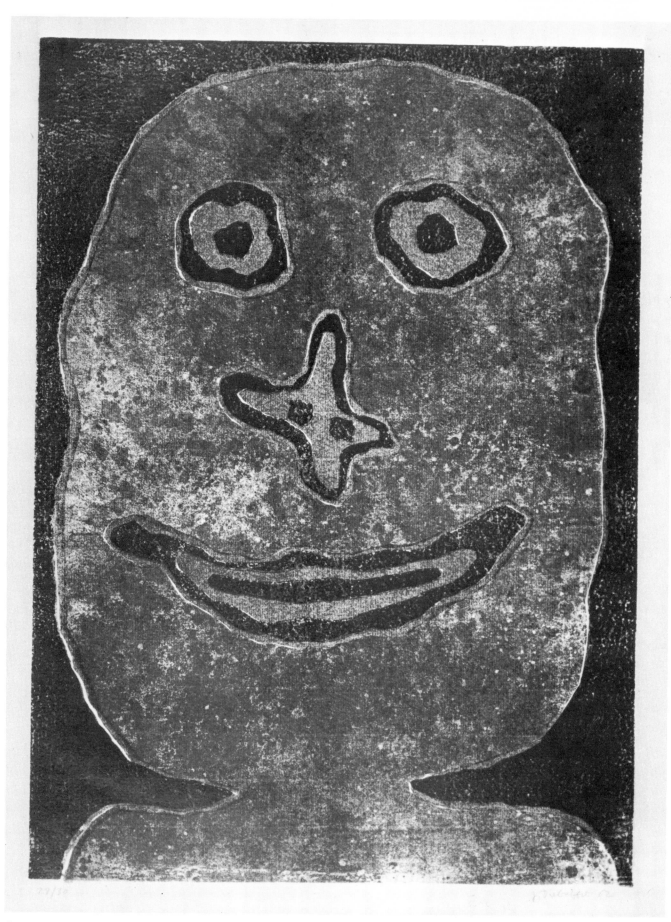

Sourire (1962), Jean Dubuffet. (Courtesy of Martin-Gordon Gallery. Photo, Geoffrey Clements)

PLATE CLEANING WITH CALCIUM CARBONATE

If dirt or persistent scumming occurs on the surface of a zinc plate, it may be cleaned with a mixture of calcium carbonate and gum etch.

Method
1. Fully roll up the plate.
2. Talc the image.
3. Saturate a piece of felt with the calcium-carbonate solution and rub off scum or dirt. Periodically sponge the area to see if the dirt is being removed.
4. When the plate is clean, sponge the entire surface and allow to dry.
5. Etch the entire plate with a solution of 50 percent Hanco Acidified gum etch and 50 percent gum arabic for approximately two and a half minutes.
6. Wipe down with cheesecloth.
7. Wash out and roll up. *Note:* If a long run is desired, the Lacquer C method may be used.

Calcium-Carbonate Solution

2 ounces gum arabic
Calcium carbonate
¼ ounce Hanco Acidified Gum Etch
Add calcium carbonate to gum arabic until a thick paste is produced; then add gum etch.

CORRECTIONS AND DELETIONS ON METAL PLATES

The first three techniques described—honing, abrasion, and solvents—are used to make corrections and deletions before etching a plate.

Honing

This technique is best used for the deletion of small areas.

Method
1. Talc.
2. With razor blade, shape the hone for edge needed to make the desired erasure.
3. Erase, sponging to see if deletion has been made.
4. Allow to dry.
5. Etch the entire plate for two and a half minutes.

Supplies

Weldon Roberts Retouch Transfer Sticks or Pink Pearl erasers
Razor blade
Sponge
Etching solution (50 percent Hanco Acidified gum etch and 50 percent gum arabic)

Abrasion

This technique may be used to create textures and tonalities. It is best employed on litho stones, but it may be used on plates if handled carefully.

Method
1. Talc.
2. Abrade the surface to the desired texture or tonality.
3. Etch the entire plate for two and a half minutes.

Supplies

Sandpaper, razor blade, or other abrasive
Etching solution (50 percent Hanco Acidified gum etch and 50 percent gum arabic)

Solvents

This technique may be used to delete large areas of a drawing and to create textures and tonalities.

Method
1. Dampen clean rag with solvent and rub area to be removed. Continue until desired effect is achieved.
2. When total removal of image is desired, continue washout with solvent until image is removed.
3. Talc.
4. Etch the entire plate for two and a half minutes.

Supplies

Lacquer thinner, benzine, or other solvent
Clean, soft rag
Etching solution (50 percent Hanco Acidified gum etch and 50 percent gum arabic)

Note: Honing, abrasion, and solvents may also be used to make corrections and deletions *after* a plate has been etched. Instead of etching the entire plate, in this case, it is only necessary to spot-etch the deleted areas with undiluted Hanco Acidified gum etch.

Acid Biting

Supplies

Hanco Acidified gum etch
Sponge

Method

1. Apply etching solution. Allow to stand until desired intensity or texture is reached. Periodically roll up image to see how much has been deleted.
2. Wipe etch off carefully with dampened sponge.
3. Roll up.
4. Dry.
5. Etch the entire plate.

Caustic Removal

This method is used for total removal of areas.

Supplies

Saturated solution of lye and water
Rubber gloves
Absorbent cotton
Felt

Method

1. Wrap cotton around a stick and, wearing rubber gloves, rub lye solution onto areas to be removed.
2. After bubbling has commenced, flood the plate with water.
3. Rub area to be removed with felt.
4. Repeat steps 1 through 3 until image is removed.
5. Roll up.
6. Dry.
7. Talc.
8. Etch the entire plate.

Lithpaco Plate Cleaner and 3M Brand Cleaner Conditioner

These cleaners may be used to delete large areas on a plate without destroying the surface grain. Deleted areas must be re-etched (the cleaners remove the grease and the gum film). Lithpaco and 3M are solutions that are easily controlled because of their viscosity, and they are recommended over other, less viscous, products.

Harris Alum-O-Lith Plate Conditioner

Note: Do not use this conditioner on zinc plates.

Under normal printing conditions, employ Harris plate conditioner only when ink manipulations and a fountain solution have failed to eliminate scumming on the plate. To use the plate conditioner, roll up the image, dry the plate, talc the surface, and apply the cleaner to scummed areas with a wad of cotton.

ADDITIONS ON METAL PLATES

Supplies

Counteretch solutions (see above, this chapter)
Etching solution (50 percent Hanco Acidified gum etch and 50 percent gum arabic for zinc; Pitman Uniclean Etch for aluminum)
Sponge

Method

1. Roll up fully.
2. Talc.
3. Counteretch the desired area for approximately two minutes.
4. Wipe off with wet sponge.
5. Dry.
6. Redraw.
7. Talc the addition.
8. Etch the entire plate for approximately two and a half minutes.

Color Lithography

Color lithography is a highly complex and intricate process which requires a thorough understanding of color theory as well as of lithographic technique. The original color drawing should be treated as a guide for the final print, not as a finished work to be duplicated exactly.

The technical procedure and the original drawing, therefore, are both important factors in producing fine color lithographs. Details such as the texture and color of the paper, the transparency or opacity of the ink, the overprinting of ink, and the textures created by the drawn image are all to be weighed and considered.

The first step in color lithography is to decide on the number of stones or plates necessary to accomplish the drawing that you have conceived. This is determined by the number of colors in the drawing. Pay attention to small areas of color as well as technical color-rolling considerations, because in some cases two or even three colors (depending on their placement) may be rolled on a single stone or plate.

COLOR SEPARATIONS

Making color separations from the original drawing clearly establishes the different colors in a print. Separations are made by tracing each color onto a separate sheet of tracing paper, and then the type of registration desired, as well as the sequence of printing, can be determined.

Method

1. Adhere the original color drawing to a large sheet of white paper.
2. Draw two crosses, as illustrated in Figure 6-1. The size of the margin establishes the distance from the image to the cross; upon completion of the print, the crosses may be removed. The crosses allow exact registration of each overlay, and may also be used on the color separations for easy transfer to the stones or plates.
3. Place the first sheet of tracing paper over the drawing, tracé the crosses, and then trace the color area to be separated from the original drawing.
4. Remove the first sheet of tracing paper, place a second one over the drawing, trace the crosses, and then trace the next color.
5. Continue until all color separations are executed.
6. Check the tracings against the original drawing by lining up the crosses on all the separations with those on the original drawing.

Supplies

Sheet or white paper (the size of the sheet is determined by the size of the original drawing plus the margins desired in the final lithograph)

Sheets of tracing paper (as many as needed for the range of colors in the original drawing)

Non-greasy drawing material (felt-tip pen, fountain pen, opaque ink, or any material that will adhere to the tracing paper without smudging)

6-1 Registration in color separation

1st color

2nd color

combined colors producing final print

TRANSFERRING SEPARATIONS TO THE STONE OR PLATE

Note: Do not transfer separations until the type of registration to be used in printing has been established.

Supplies

Non-greasy drawing material (conté crayon, jeweler's rouge, charcoal, etc.)
Ball-point pen (this allows you to see the image as you draw)
Lithographic drawing materials (tusche, crayon, etc.)

Method

1. Rub the front of the separation with the non-greasy drawing material or rub conté crayon on the back of the tracing. Cover the image and the register marks. *Note:* Be sure to use a grease-free drawing material, which can be removed easily from the plate or stone.
2. Place coated side of tracing paper down on the plate or stone. If the separation is coated on the back and placed drawing-side up, a mirror image of the original drawing will result.
3. With a ball-point pen, draw the outlines of the area to be transferred. Do not press too hard, since excessive pressure will dent metal plates or tear the tracing, causing ink from the ball-point pen to transfer and even print.
4. Remove separation. A clear outline of the area to be drawn is now visible.
5. Draw the image, using the selected lithographic drawing materials.

T REGISTRATION

T registration (Figure 6-2) may be used for all types of work. However, the edition paper must be 1½″ smaller in all dimensions than the plate or stone. In addition, if precise registration is desired, this method must be executed with great care.

Note: Before proceeding, it is necessary to calculate the number of prints to be pulled by multiplying the number of prints in the edition by the number of color plates. For example, an edition of fifty lithographs printed from three plates produces a run of 150 impressions. Overrunning is necessary to insure the completion of a full edition, and the skill of the printer determines the amount of overrunning necessary. Do not overlook the requirements of color proofing, registration errors, and printing errors.

Method
1. Place the color separation in the center of the plate or stone and transfer the image as described above.
2. On the back of each sheet of the paper for the edition, mark the center, top and bottom, with a line. Cross one of these lines with a second line to designate the top.
3. Place a sheet of marked paper face down on the plate. The paper should be centered over the image.
4. Extend register marks from the back of the paper onto the plate. Remove the paper and draw a horizontal line across the end of the register mark at the "top" end of the plate. This will form a T, coinciding with the cross on the paper (see Figure 6-2). During printing, align the marks on the back of the paper with the marks on the plate or stone.
5. Repeat the above procedure for each color.

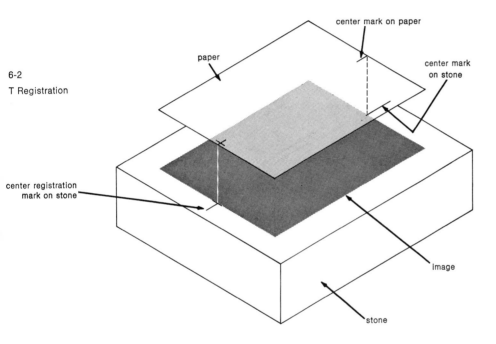

6-2

T Registration

CHANGING OR ADDING REGISTRATION MARKS

1. Print image and registration marks (if they exist) onto a sheet of mylar or acetate.
2. Place over a previously printed image and align the two.
3. Make a piece of carbon type paper by marking a piece of paper with pencil strokes.
4. Place these pieces between the newly aligned acetate and the proof under the existing registration marks on the acetate.
5. Trace the registration marks onto the printed proof by tracing over the marks on the acetate sheet.
6. Hold the proof up to the light and trace the marks onto the back of the sheet.
7. Erase or cross-out the old registration marks.

PINPOINT REGISTRATION

For the most precise registration, pinpoint registration (Figures 6-3 and 6-4) is recommended. When using pinpoint registration, register marks must be duplicated along with the image.

Method

1. Transfer the image and register marks from the separation to the plate or stone as described above.
2. Print first run using the T-registration method. Be sure to print the register marks as well as the image.
3. Thoroughly dust a freshly printed impression of the run with jeweler's rouge, removing excess powder. Lay the dusted side face down in the center of the second plate or stone. Run through the press under light pressure. The dusted image will offset.
4. Align the second color separation with the offset register marks. This procedure indicates the precise area where the second color must be drawn.
5. Draw in the second color, including register marks. Prepare plate or stone in usual manner for printing.
6. Place a stylus or etching needle at the intersection of the registration cross and bore a tiny hole into the surface of the plate or stone. This hole will prevent movement of the pin.
7. Puncture the registration crosses on the print with two pins (hat pins are recommended). Align the pins with the holes on the plate or stone. Now begin printing the second run.
8. Continue printing in the usual manner, repeating registration method for additional colors.

Note: If there is a dominant plate—one that contains an outline drawing or major image—it should be proofed first. The number of proofs pulled of this plate is determined by the number of colors in the image. By transferring these proofs to the remaining plates, exact placement of these colors will be possible.

6-3, 6-4 Pinpoint registration

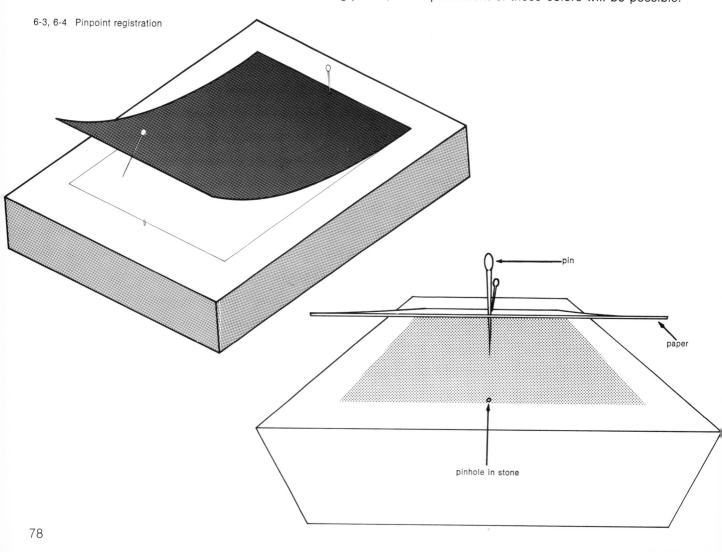

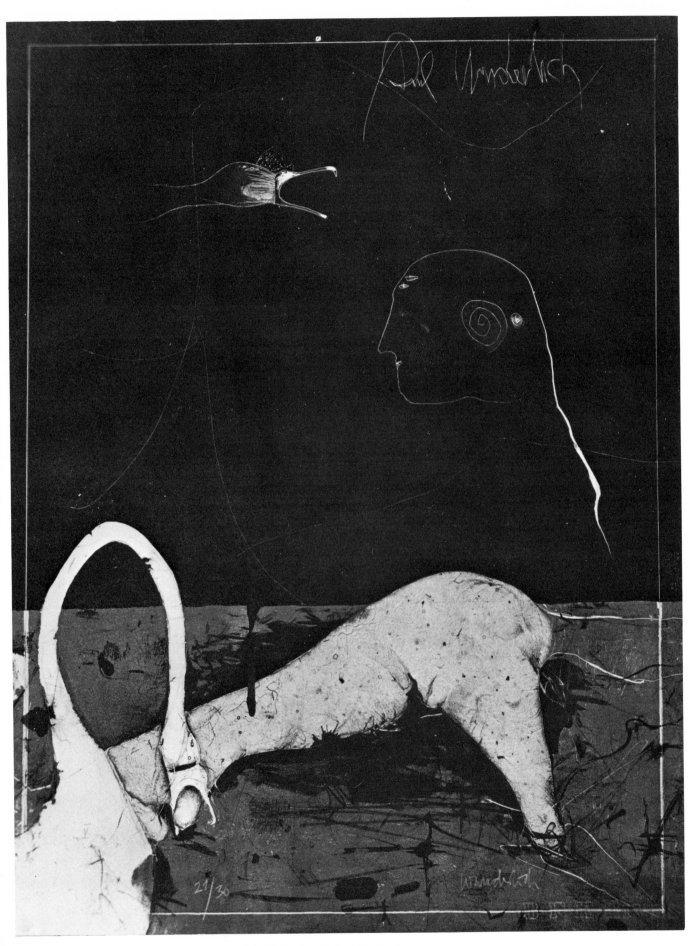

Leda and the Swan, Blatt 4 (1963), Paul Wunderlich. (Collection, Robert Denison)

COLOR PRINTING BY DELETION

Another effective way to create a multicolored lithograph is to delete part of an image from a single plate or stone and reroll the remaining image with a second color. The image may be erased by honing or by acid burning or chemical removal (see Chapter 10). Be sure to provide for proper registration by using one of the two techniques described above.

PREPARING THE STONE OR PLATE FOR COLOR PRINTING

Preparation of a stone or plate for color printing is the same as for printing in black, since the image is drawn with the same materials. However, the rub-up procedure is different in that the appropriate color must be used instead of Triple Ink or asphaltum.

Note: Roll up the stone or plate with black before proceeding to the second etch. Black ink is more acid resistant than colored ink.

As explained in Chapter 1, composition rollers are used in color printing. Do not use cuffs when printing light colors, since the friction between roller handle and cuff produces lint, which will discolor and mar the light-colored areas. Ink build-up should be gradual; because there is no nap on composition rollers, it is difficult to roll rapidly and to pick up excess ink.

Finally, follow the same rolling pattern as for black-and-white printing. This will eliminate roller marks and insure even surface inking.

COLOR PRINTING

Use of a fountain solution is recommended to help prevent scumming, bleeding, and filling in of the image in color printing. Sponge the fountain solution across the image after a few passes have been made. The deposit of a thin layer of ink on the image provides an acid-resistant coating, preventing the fountain solution from burning the image.

Change the water for sponging the stone or plate as soon as it becomes dirty. Sponging with dirty water deposits scum on the printing surface, and this will be transferred to the paper, ruining the print.

If a color run is not completed, do not roll up the stone or plate with colored ink for storage purposes. Talc the image, gum and wash out the colored ink with lithotine, rub up with asphaltum, and wrap the stone or plate with newsprint. When you return to print, be sure to wash out the asphaltum with lithotine and rub up with the appropriate color.

Transfer Paper

Transfer paper is an exceedingly valuable material. It is light in weight and easily transportable. It can be used to make frottages (surface rubbings) of interesting textures, an impossible procedure with plates or stones. Also, the inhibiting factors of a plate or a stone are eliminated by using transfer paper to draw on as if it were a regular sheet of paper.

Daisy, Daisy, Allen Jones. (Editions Alecto, London) 1965

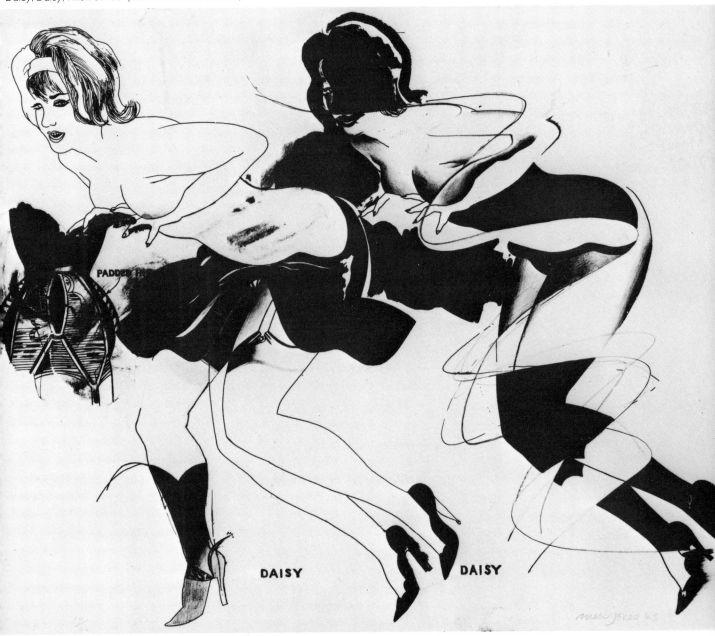

The transfer papers available today are of such high quality that they permit accurate transfer of the drawing to the surface of the plate or stone in a reversed state. Thus, the printed proof is the same as the actual drawing and not its mirror image. By pulling a transfer and setting it aside in case the stone or plate breaks down in the course of printing, you can use transfer paper as a safeguard, assuring the completion of long editions.

Transfer paper also has disadvantages, which can limit artistic expression in lithography. Most papers have a water-soluble surface such as gum or glycerin, prohibiting the use of water washes. Many of the interesting special techniques, such as acid burning and abrading, are not possible either, because of the fragile quality of the paper. Basically, drawings can only be done in a positive way.

The two transfer papers discussed here have water-soluble surfaces, so they cannot be treated with water tusche, gum stopouts, or any other liquid which will dissolve their surface. But acrylic paint can be substituted for gum stopout. A second sheet of transfer paper may be pasted onto the surface of the stopout, producing the effect of an overdrawing. And by assembling pieces of transfer paper, collage effects may be realized.

CHARBONNEL TRANSFER PAPER (OPAQUE WHITE) AND TRANSPARENT

This paper measures 23½″ by 35½″ and is .004″ thick. It is white in color. Make direct drawings with litho pencils, rubbing ink, turpentine or other solvents, tusche, asphaltum, etc. Charbonnel transfer paper may be used for direct transfers, plate to plate and stone to stone.

Note: It is advisable for two people to work together when pulling a transfer. It is also advisable to use new transfer paper. Old paper will stick and thus be very difficult to remove without disturbing the image.

Supplies

Bucket with very hot water
Counter-etch solution
Clean sponge
New blotters

Method

1. The pressure needed for transferring an image must be determined before proceeding. Adjust the pressure by covering the stone or plate with a sheet of newsprint and two new blotters. Use moderately heavy pressure.
2. Using a Conté crayon indicate where the transfer paper will be placed on the surface of the plate or stone.
3. With hot water, dampen the surface of a freshly counter-etched stone or plate.
4. Standing on opposite sides of the press, hold the transfer paper taut and position it on the surface. (Make sure that it is absolutely flat and there are no wrinkles.)
5. Immediately place a hand in the middle of the back of the transfer and cover it with a sheet of newsprint and two blotters.
6. Proceed to run the transfer through, forwards and backwards at least 6 times in both directions.

 Note: Have your partner distribute the grease in the front and the back of the scraper bar while the person on the printer's side cranks the press.

7. Remove the newsprint and blotters and soak the back of the transfer paper with hot water for approximately five minutes. (Do not allow excess water to seep underneath the transfer paper, for it might smear the image.)
8. Dry off the back of the transfer paper and slowly peel it off on a diagonal.
9. Dry the image.
10. Rosin and talc (stone); talc (plate).
11. Gum the entire image. Keep the gum moving for approximately 5 minutes.
12. Wipe down and buff dry with cheesecloth.
13. Leave for approximately 2 hours or longer, then wash-out, roll-up and etch according to the first etch cycle.

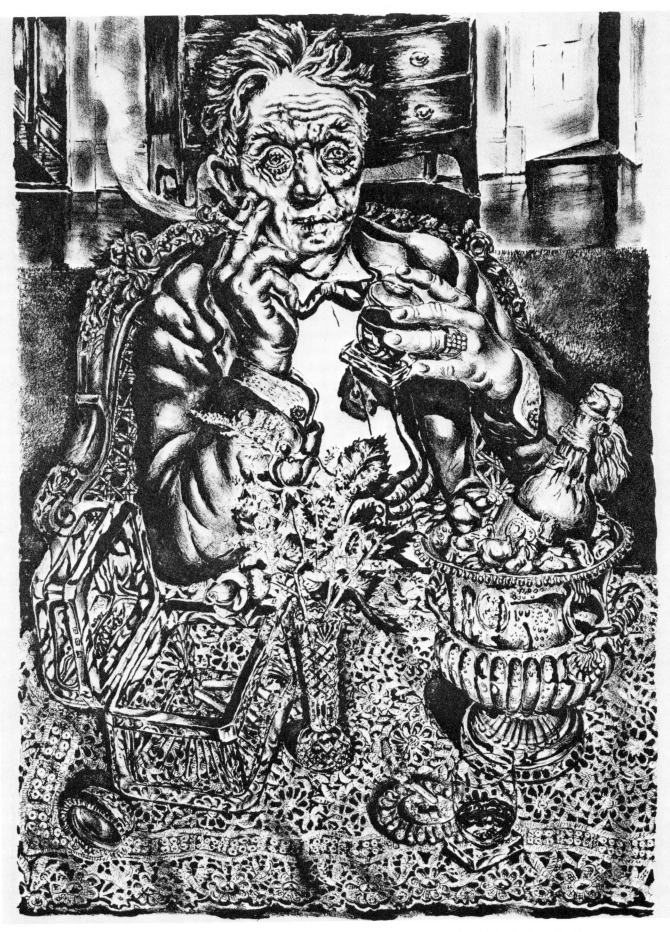

Self-Portrait—55 Division Street (1947), Ivan Albright. (Collection, The Museum of Modern Art, New York. Purchase Fund)

TRANSFERRING FROM PLATE TO PLATE OR STONE TO STONE

Be sure to use one part Charbonnel Retransfer ink to two parts roll-up black when rolling up the plate or stone. Because transfer ink is often stiff, it may be necessary to add 470 reducing oil. Follow the same procedure described above.

GERMAN EVERDAMP

This paper is 19″ by 25″ in size and has a thickness of .0065″. It is dirty yellow in color and feels like newsprint. It must be stored in a sealed container to retain its dampness. This paper is best used for direct transfers.

Method
1. Place the transfer paper drawing face down on the plate or litho stone. Pass through the press three times under medium pressure. Remove the transfer paper.
2. Rosin, talc, gum-etch, and wipe down with cheesecloth.
3. Let dry for approximately fifteen minutes.
4. Roll up and etch as usual.

Paper

Papyrus, parchment, and paper are materials that have transmitted thoughts and images through several millennia, providing much of our knowledge about previous centuries and civilizations. Many of the illuminating documents from the past would not be available today if previous generations had employed contemporary mass papermaking techniques. As lithographers, we are particularly interested in paper, because the beauty and durability of a print depends on the quality of the stock upon which it is printed.

There are two kinds of papers, those made by hand and those made by machine. So-called mold-made papers are made by machines but have the quality of handmade papers.

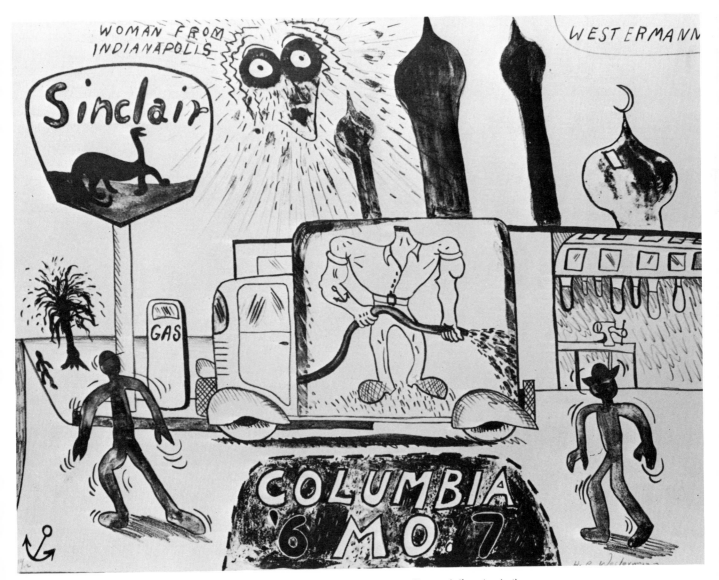

Woman from Indianapolis, H. C. Westermann. (Courtesy of Brooke Alexander. Photo, Jeffrey Loubet)

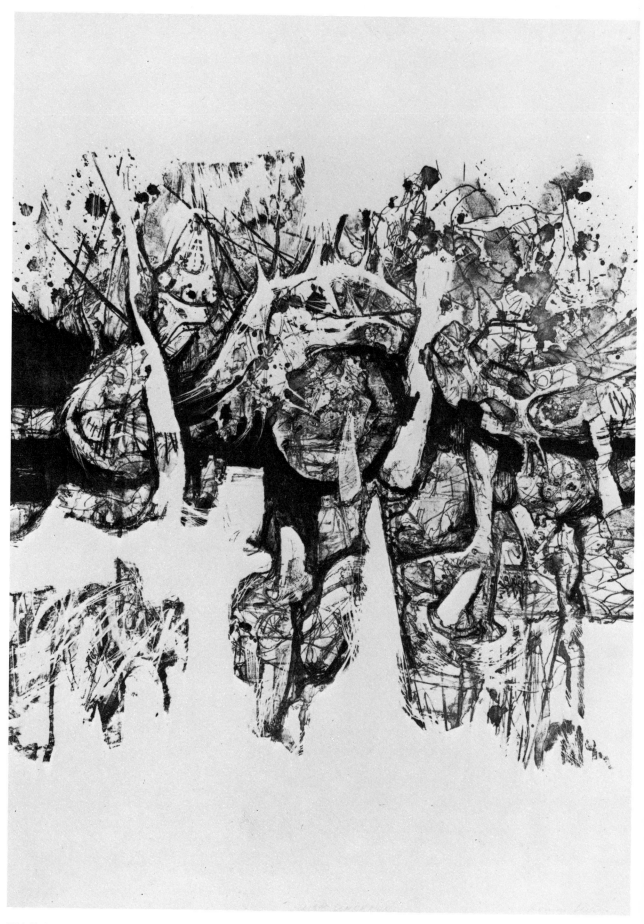

With Unknown, Romas Viesulis. (Photo, Malcolm Varon)

HANDMADE PAPERS

Handmade papers are strong, durable, colorfast, texturally beautiful, and expensive. The fibers differ according to the geographic origin of the papers. The papers made in Japan are of vegetable fibers, while papers manufactured in the West are made from rags—cotton, linen, or a mixture of the two. The rag papers are inherently more opaque than the vegetable fiber papers.

The first step in the Japanese papermaking process is to form a fibrous pulp of the vegetable fibers; next, a paper mold is dipped into the solution. The formed sheets are then removed and stacked one upon another until they are dry. The dry paper may be sized with starch or gypsum.

Paper making is more complex in the West. The rags are macerated to form pulp; then a *vatman* dips the mold into the pulp, shaking the solution until it is evenly distributed over the mold. Next, a *coucher* lays the newly formed sheet, called a post, between felt blankets by turning the mold upside down and allowing the sheet to drop out. The post is put into a hydraulic press to squeeze out all excess water; the amount of pressure used depends upon the type of paper being made. A *layman* piles the pressed sheets onto a table, removing the felts and returning them to the coucher. Finally, a *dry worker* hangs up the sheets to dry in an area where air circulates freely. After the paper has dried, it is sized and glazed. In the West, most sizing is prepared from animal bones, hides, and hoofs. Glazed finishes on the surface of the paper are created by sending the sheet through the rollers again.

Careful examination of handmade papers reveals many common characteristics. Each of the four sides of a sheet of handmade paper has a slightly irregular edge, which is called a deckle edge. The deckle, a removable frame, fits over the mold, forming a raised border. It prevents the fibrous solution from pouring over the edges of the mold and determines the size of the sheet. The deckle edge is formed when the fibrous liquid seeps under the edges of the frame.

When handmade paper is held up to the light, a design called a watermark may be seen. These identifying marks are made by weaving a pattern into the mold wires to form an emblem, name, or symbol. Many fine papers are distinguished by their watermarks.

MACHINE-MADE PAPERS

Although machine-made papers are cheap and good for proofing, they are less durable and attractive than handmade papers, have a tendency to discolor, and give inferior results compared with handmade papers.

Wood pulp is the primary ingredient of most machine-made papers. Three types of pulp are commonly used today. Mechanically ground wood pulp is formed when the entire log, except for the bark, is pulverized. This process produces short fibers, and, because the pulp contains fugitive substances, the resulting paper discolors, has little strength, and finally disintegrates.

The second common pulp paper is made by reusing old paper. Chemicals remove the old ink and return the paper to its pulp state. Again, the fibers formed are short, and the resulting paper is similar to mechanically ground wood pulp papers.

Chemical wood pulp is made with wood chips, which are cooked in a digester to remove most of the harmful substances. The result is a long-fiber paper which is relatively strong and durable.

After the wood, old paper, rags, or other raw materials have been reduced to a pulp state, the fibers are beaten, roughened, and refined. Then the solution is sized, a process which strengthens the fibers and prevents writing and printing inks from blurring once the paper reaches its final form. Resin and starch are commonly used to size machine-made papers. The loading phase is next—clay

is added to the pulp to increase the brightness and opacity of the paper. The final step takes the fibers into the forming machine, where the pulp is diluted with water in a large vat and then transferred to a continuous wire mesh screen. While traveling on the screen at high speed, the fibrous solution is shaken from side to side to allow the water to drain off and the fibers to mesh. The paper is then placed between felt blankets and carried through the rollers to remove excess water.

The best machine-made papers are marked W.F. (wood free). Although the quality of machine-made papers can be improved with the addition of rags or the exclusion of chemical wood pulp, this is not often done. Since as artist-craftsmen we are concerned with durability and quality, handmade papers are obviously preferable. The following table lists the papers suitable for lithography.

PAPERS AND THEIR PROPERTIES

All of the following papers are suitable for lithography. They are low in acid content and of the highest quality. The weight measurements given are in pounds per ream and grams per square meter.

Name	Manufacturer	Colors	Size in Inches	Weight	Method of Preparation	Rag Content
Arches Cover	Arches Mill, Vosges, France	White Buff	22 x 30	120 lbs. 240 gms.	Mold-made	100%

Properties: Prolonged light exposure will darken white and fade buff. Excellent surface that erases easily. Best printed with soft ink and high pressure. Stretches slightly. Takes color well.

Rives BFK	Rives Mill, Isère, France	White	22 x 30	110 lbs. 230 gms.	Mold-made	100%
			29 x 41	220 lbs. 250 gms.		

Properties: Lightfast. Excellent surface that picks up minute details and erases well. Requires heavy inking, especially for color wash. Stretches slightly. Heavy color inking may dry to shiny finish. Considerable pressure necessary or paper will curl.

Rives Heavy Weight	Rives Mill, Isère, France	White Buff	26 x 40	120 lbs. 175 gms.	Mold-made	100%

Properties: Same as Rives BFK but will not curl upon drying.

Copperplate	Papier-fabrik Zerkall, Renker and Soehne, Germany	White	30 x 42 Available in half size	220 lbs. 250 gms.	Mold-made	33%

Properties: Turns whiter with time. Rough texture. Erases well. Requires heavy inking and pressure. Stretches slightly. Takes color well. May be used as a fine proofing paper.

Copperplate Deluxe	Papier-fabrik Zerkall, Renker and Soehne, Germany	White	30 x 42 Available in half size	220 lbs. 250 grms.	Mold-made	75%

Properties: Copperplate Deluxe is a finer paper than Copperplate because of its higher rag content.

German Etching	Hahnemuehle, Germany	Yellow-white	31¼ x 42½ Available in half size	260 lbs. 300 gms.	Mold-made	75-80%

Properties: Lightfast. Soft paper. Does not erase well. Needs heavy inking and pressure. Good for color wash. Stretches slightly.

Name	Manufacturer	Colors	Size in Inches	Weight	Method of Preparation	Rag Content
English Etching	J. Barcham Green, England	White	23 x 31	140 lbs. 300 gms.	Mold-made	100%

Properties: Lightfast. Hard paper. Does not erase well. Not good for color wash. Heavy inking and pressure required for washes. Stretches slightly. Good for crayon work.

Name	Manufacturer	Colors	Size in Inches	Weight	Method of Preparation	Rag Content
Crisbrook Waterleaf	J. Barcham Green, England	White	22 x 31	140 lbs. 300 gms.	Handmade	100%

Properties: Lightfast. Hard paper. Does not erase well. Limited absorption ability. Stretches slightly. Very heavy pressure needed for washes. Often contains dark specks which disturb surface. Good for crayon work.

Name	Manufacturer	Colors	Size in Inches	Weight	Method of Preparation	Rag Content
Italia	Cartiere a Mano Enrico Magnani, Italy	White	28 x 40 Available in half size	220 lbs. 300 gms.	Mold-made	66%

Properties: Colorfast. Heavy and hard. Not very absorbent. Not good for color solids; dries color overlays to a shiny finish. Stretches slightly. Good for crayon work.

Name	Manufacturer	Colors	Size in Inches	Weight	Method of Preparation	Rag Content
Inomachi (Nacre)	Kawaguchi Mill, Gigu Prefecture, Japan	White Natural	20 x 26	55 lbs. 114 gms.	Handmade	80% Kozo (fiber)

Properties: Irregular shape, size, and thickness make tight color registration difficult. If loose registration is used, it will print well. Very strong. A very fibery appearance gives it a sumptuous and rich look.

Name	Manufacturer	Colors	Size in Inches	Weight	Method of Preparation	Rag Content
Laga Velin Blanc Narcisse	Moulin à Papier du Val de Laga, France	White	20 x 25	90 lbs. 240 gms.	Handmade	100%

Properties: Irregular shape, size, and thickness make color registration difficult. Very beautiful surface. Erases well. Stretches in printing.

Other papers may be used, although their low rag content may present preservation problems. Generally, the following papers may be used for proofing.

Name	Manufacturer	Colors	Size in Inches	Weight	Method of Preparation	Rag Content
Domestic Etching	Curtis Paper Co.	White	26 x 40	120 lbs. 175 gms.	Machine-made	50%

Properties: Similar to Rives BFK.

Name	Manufacturer	Colors	Size in Inches	Weight	Method of Preparation	Rag Content
American Etching		Off-white	38 x 50	450 lbs. 300 gms.	Machine-made	100%

Properties: Lightfast. Very stiff paper. Does not erase well. Requires heavy pressure and heavy inking. Stretches slightly. Takes color well.

(The authors would like to acknowledge the Andrews/Nelson/Whitehead Company, New York, and the Tamarind Lithographic Workshop, Los Angeles, for supplying much of the above information.)

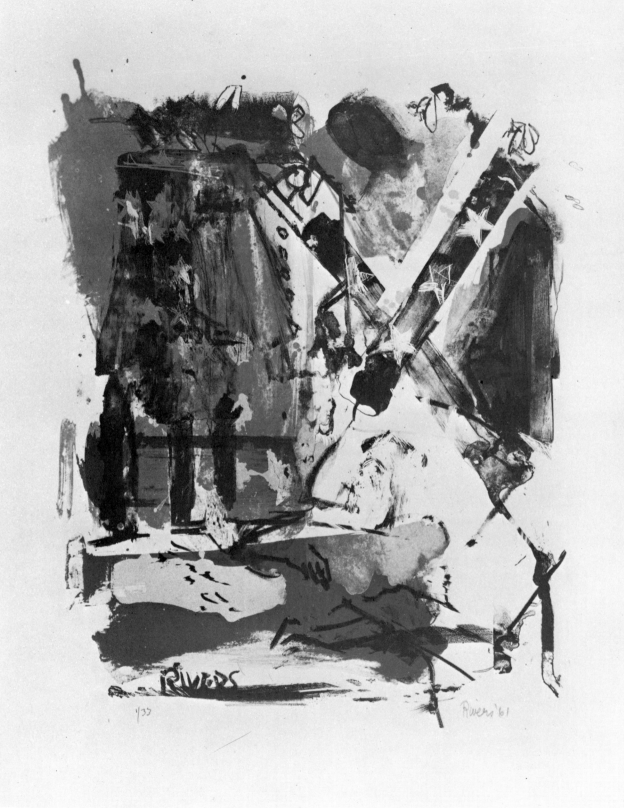

Last Civil War Veteran II (1961), Larry Rivers. (Collection, The Museum of Modern Art, New York. Gift of Celeste and Armand Bartos Fund)

CAUSES OF DAMAGE TO PAPER AND WAYS OF PREVENTING DAMAGE

Paper is very fragile and easily damaged. Not taking proper care when storing and presenting prints is wasteful and expensive. Paper must be protected from certain atmospheric conditions, chemical pollutants, and pests to which it is highly sensitive.

Excessive wetness or humidity weakens the adhesives that hold the fibers together in paper, straining the fibers. This may cause the surface to ripple and distort the image. Too much humidity may also rot the sizing agent, causing mildew and fungi (foxing). Finally, the image may be ruined by blurring of ink as a result of any one or a combination of these factors.

On the other hand, excessive dryness will make the paper brittle, eventually causing it to crack or split.

Overexposure to light, even if most of the ultraviolet rays are filtered out, will discolor paper and make it brittle. Excessive heat will make it warp and stretch.

Needless to say, there are innumerable chemicals which can damage paper. It is well known that the atmosphere of large cities contains excessive amounts of soot, dust, sulfur dioxide, carbon dioxide, and hydrogen sulfide. The extent to which these pollutants affect paper is often not realized. Soot and dust will cause staining and discoloration; large amounts of sulfur dioxide will cause bleaching and discoloration, and hydrogen sulfide will darken some pigments.

Many insects, such as moths, wood beetles, and silverfish, are attracted to paper or the substance used to size it. Larger pests like mice have also been known to use paper to build their nests.

Finally, paper must be kept away from materials that contaminate it. Because of the acidic nature of most machine-made papers, wood-pulp mounting board or mat board will discolor prints and cause physical deterioration of the paper over a period of time.

A few simple precautions will prevent unnecessary damage to paper. In general, it should be stored in an enclosed space which is dry and well ventilated. It should not be exposed to rapid changes or extremes of temperature or humidity, or to atmospheric contamination. If paper has been wet for printing, always allow the prints to become thoroughly dry before stacking and storing the edition. The slip sheets between prints must be removed after the prints are dry. Prints should never be matted or mounted on acidic pulp paper or board.

A print will retain its original appearance and physical strength if these simple precautions are taken.

Printing Inks and Additives

Lithographic inks are manufactured especially to print on flat surfaces. They are made of two substances—the pigment or color and the vehicle or medium. Except for whites, lithographic inks are either semitransparent or transparent. (Here, "transparency" describes an attribute of the pigment; it is not a product of the additives.) The amount of vehicle absorbed by the ink affects its transparency.

The vehicle has two important roles. It acts as the holding and transferring medium through which the pigment is distributed first onto the roller, then onto the printing surface, and finally onto the paper. In addition, the vehicle sets or hardens, binding the pigment to the paper and producing a consistent surface. By heating drying oils at different temperatures, numerous kinds of litho varnishes (or mediums) are created. Linseed-oil varnish is a highly suitable vehicle, because it contains the greasy qualities needed in a well-balanced ink for rolling it onto a plate or stone.

It is essential that the pigment be dispersed evenly and thoroughly throughout the vehicle to prevent piling (a dry caking on the printing surface), which causes uneven distribution of ink and wear and tear on the plate. Because of the presence of water and acid during the printing process, the combination of pigment and vehicle must resist these substances. Lithographic inks must also be permanent and lightfast. Their color should be strong, because the ink film deposited onto the paper is very thin. Finally, the inks must have the proper stretching qualities and consistency—neither too hard nor too soft.

The specific needs of a printing job may be met by combining several additives with the inks. Because of temperature and humidity changes, mix only the quantity of ink needed for the run that can be accomplished at one time.

REDUCING OIL

Reducing oil is like a non-greasy solvent. It is used chiefly in running large, flat areas because it softens the body of the ink, which helps to eliminate roller marks. Number 470 Sinclair and Valentine Reducing Oil is recommended for the hand lithographic process.

Never use reducing oil on metal plates—it often causes heavy scumming; use only varnish on metal plates. Reducing oil and varnish should never be combined in a single ink mixture because they react against each other.

VARNISHES

Varnishes are made in grades ranging from #00000 to #10. The lower the number, the softer the varnish. Number 00000 through #000 are too thin for hand lithographic work. Number 00 through #2 are so similar to each other that they can be used interchangeably. They exhibit excellent results, since they mix well with the lithographic inks. Also, the varnishes in this range smooth the ink and prevent marking. The ink is softened so that flattening and meshing can take place in the inked area. The elimination of roller marks permits the even inking of large areas of solid color.

Number 6 through #8 varnishes enhance the trapping qualities of an ink; that is, they prevent the rejection of one color by another during overprinting. Varnishes of grades higher than #8 are too stiff for hand lithographic work.

Excess varnish in many colored inks causes bleeding. Take great care with the following colors: thalo-blue-red, thalo-blue-green, and permanent rose red. If varnish must be mixed with these colors, bleeding can be controlled by adding magnesium carbonate to the ink.

MAGNESIUM CARBONATE

Magnesium carbonate stiffens ink. The specific job determines the amount needed. Magnesium carbonate can also be added to the sponging water, which may prevent scumming and bleeding of the image. The procedure should only be used once per printing. Then sponges have to be washed and the water discarded, since magnesium carbonate will solidify the ink on the roller.

SETSWELL REDUCING COMPOUND

Setswell Reducing Compound, manufactured by the Handschy Chemical Company, is basically a wax compound. It is used as an aid in trapping and overcoming push (paper slippage on a large, flat area, which causes the surface to ripple). Adding this compound to the ink also reduces roller marks, prevents surface gloss in colored ink overlays, and allows the meshing of colored overlays.

PARAFFIN

Paraffin helps trapping, softens ink, and flattens color. It may also be used to retard drying. It is similar to and interchangeable with Setswell Reducing Compound.

DRIERS

Most commercial lithographic inks contain small amounts of a drying agent. When consecutive runs of a multicolored print must be completed in a short period of time, the amount of drier may be increased. This forces the color to dry very quickly, so that overprinting can take place. Extreme caution must be taken when using driers. Too much will cause the inking surface, and the ink on the roller, to harden.

DRIER RETARDERS

Drier retarders are used when running large solid areas to prevent the ink from setting too quickly, which causes roller marks. Extremely small quantities of retarder should be used. Too much may keep the ink from drying for months.

METALLIC AND DAYLIGHT FLUORESCENT INKS

Metallic inks are produced by mixing metallic powders with a synthetic resin. For example, gold metallic ink is a mixture of bronze powder and a synthetic resin. Numerous other colors are created by overprinting transparent inks on metallic hues. Metallic effects may also be obtained by printing with #5 or #6 varnish and dusting metallic powder over the varnish while still wet.

Although fluorescent inks provide interesting visual effects, you should carefully consider their disadvantages before using them. They have absolutely no permanency. They cannot be mixed effectively; if two or more inks are combined, the fluorescence is lost. Finally, only a limited number of colors is available.

RECOMMENDED LITHOGRAPHIC INKS

When requesting these inks, be sure to specify that no drier be mixed with the ink.

COLOR	MANUFACTURER	SERIAL NO.
Black		
Black	Kast-Ehinger GmbH	185 N

RECOMMENDED LITHOGRAPHIC INKS (Continued)

COLOR	MANUFACTURER	SERIAL NO.
Stone Neutral Black	Sinclair & Valentine	LA-76823
Noir Velour	Charbonnel	2255
Noir à Monter (Roll-Up Black)	Charbonnel	—
Offest Crayon Black	Hanco	8035
Retransfer	Charbonnel	—
Opaque White		
Opaque White	Seibold	938
Opaque White	Sinclair & Valentine	LA-71460
Opaque White	Hanco	CS-850
Yellow		
Yellow #404	Sinclair & Valentine	LA-58013
Yellow	Hanco	CS-2851
Primrose	Seibold	14585
Primrose	Kast-Ehinger	1 Q63
Special Chrome Yellow	Sinclair & Valentine	LA-71986
Orange		
NOVA-Vitorange	Kast-Ehinger	2 N 414
Policy Orange	Hanco	OR-1347
Standard Orange	Hanco	CS-200
Sun Orange	Hanco	OR-1349
Red		
NOVA-Vitrot	Kast-Ehinger	2 C 411
Fire Red	Hanco	CS-360
Vermilion Red	Sinclair & Valentine	LA-60177
Permanent Rose Red	Sinclair & Valentine	LA-67477
Blue		
NOVA-Vitblau	Kast-Ehinger	4 F 62
NOVA-Vitblau	Kast-Ehinger	4 F 64
Thalo	Hanco	CS-420
Process Blue	Seibold	122-12
Royal Blue	Sinclair & Valentine	LA-75390
#411 Blue	Sinclair & Valentine	LA-67792
Purple		
Purple	Sinclair & Valentine	LA-62547
Green		
NOVA-Vitgrün	Kast-Ehinger	5 K 402
Christmas Green	Hanco	G4996
Yellow Shade Green Toner	Hanco	G8720
Oriental Green	Sinclair & Valentine	LA-67473
Brown		
NOVA-Vitbraun	Kast-Ehinger	6 H 401
NOVA-Vitbraun	Kast-Ehinger	6 H 402
NOVA-Vitbraun	Kast-Ehinger	6 C 402
Leaf Brown	Hanco	EN-3434
Bismark Brown	Hanco	BN-3433
Autumn Brown	Sinclair & Valentine	LA-67474
Metallic Ink		
Metallic Silver	Hanco	CS-950
Metallic Rich Gold	Hanco	CS-951
Daylight Fluorescent Ink (Dayglo)		
Signal Green	Hanco	CS-3400
Saturn Yellow	Hanco	CS-3399
Blaze Orange	Hanco	CS-3397
Rocket Red	Hanco	CS-3395
Aurora Pink	Hanco	CS-3393
Transparent White		
Transparent White	Seibold	857
Flat Transparent Base	Sinclair & Valentine	LA-68294
Offset Tint Base	Hanco	W-191-X
Triple Ink	Lith-Kem-Ko	2401

Special Effects

This chapter lists a number of special techniques that are used frequently in lithography, and offers some suggestions for inventing new ones. The procedures outlined may be modified or combined with others to produce different effects. The variety of effects described here is only an outline of possibilities: from it each artist may create a vocabulary to express his own ideas.

Gyros III (1965), Henry Pearson. (Collection, The Museum of Modern Art, New York. John B. Turner Fund)

BURNING WITH ACID

This technique may be employed to remove all or part of an image. When carefully regulated, it produces a large range of grey tones. *Note:* Burning with acid alters or destroys the grain. It is not recommended for long runs. It is best suited to work on stones, but may be used on metal plates if carefully handled.

Supplies

Asphaltum
Acid-gum solutions (varying strengths)
Sponge

Method

1. Cover stone with asphaltum.
2. Draw with acid-gum solutions.
3. Wipe with damp sponge to regulate intensity once desired tonalities are reached. *Note:* Be careful not to allow the acid-gum solution to remain on the stone too long, since it may do too great damage to the surface.
4. Rosin, talc, and etch.

CHEMICAL REMOVAL OF THE IMAGE

By chemically removing an image, the regraining procedure may be eliminated. Chemical removal is also a useful technique for color work—because a ghost of the old image remains after removal, exact registration is possible. *Note:* Do not use this method instead of regraining. It is to be used only when it is necessary to retain a ghost of a previous image.

Supplies

Carbolic acid
Gasoline
Rubber gloves
Absorbent cotton
Soft rags

Method

1. Prepare a mixture of 50 percent carbolic acid and 50 percent gasoline.
2. With a cotton swab or old brush, scrub mixture onto stone or plate, removing all grease and ink. *Note:* Rubber gloves must be worn. Negligent handling of the carbolic acid-gasoline mixture can cause severe burns.
3. Wipe off excess liquid with rags.
4. Wash with water and dry.
5. Counteretch.
6. Wash off counteretch and dry.
7. Draw new image.
8. Rosin (on stone), talc, and etch.

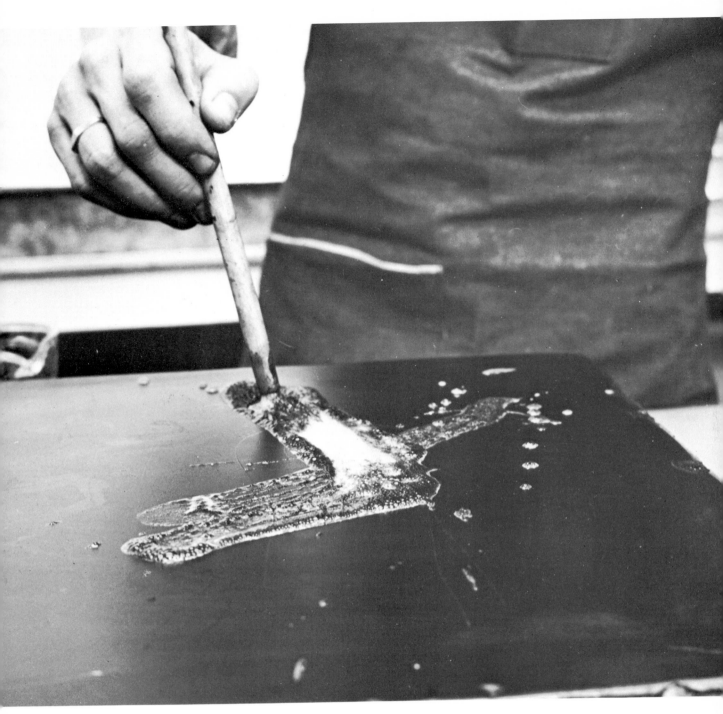

10-1 Burning with acid

FRISKETS

Distinct shapes surrounded by an embossed edge can be made with a frisket, stencil, or mat. When a small stone or plate is printed on a large sheet of paper, a mat can be used to emboss the edges of the edition paper and keep them clean.

Supplies

Paper or clear Contact paper (if prolonged use of a specific frisket is desired, be sure to use a strong, non-absorbent paper. It should not be too thick, however, or it may ruin the blotter and cause difficulties in running the edition.)

X-acto knife or razor blade

Method I

1. Cut or tear paper into desired shape. *Note:* Multiple use of the same frisket, paper, or mat may cause it to stretch and distort. If a long run is intended, prepare many identical pieces in advance.
2. Place frisket over inked image. Do not forget to establish some form of registration system for positioning the frisket.
3. Proceed to print.

Method II

1. Draw desired shape on the stone or plate.
2. Remove backing from Contact paper and place paper over entire stone or plate.
3. Using sharp blade, cut out desired shape and remove it.
4. Fill in cutout area with drawing material. Allow to dry.
5. Remove remaining Contact paper.
6. Continue to draw, or rosin (on stone), talc, and etch.

10-2 Frisket

Opposite:

Hyacinthe Rigaud (Louis XIV), Clem Clarke. (Courtesy of Brook Alexander. Photo, Jeffrey Loubet)

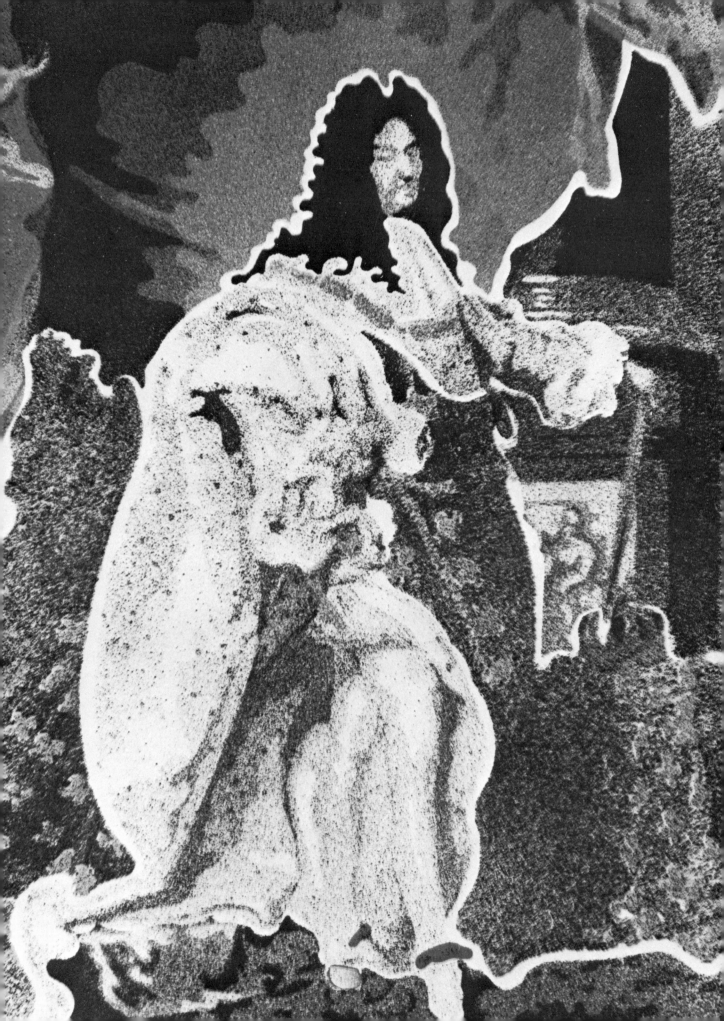

LINE DRAWINGS

Direct Drawing

Lines may be drawn directly onto the printing surface with zincographic ink and various pens, including ball-points, Rapidographs or ruling pens, etc.

Scratching

Two methods are described here. The first will produce a black line on a white ground; the second, a white line on a black ground.

Supplies

Gum-etch solution (50 percent Hanco Acidified gum etch and 50 percent gum arabic)
Stylus
Asphaltum

Method I
1. Cover stone or plate with gum etch and allow to dry. Be sure the surface is coated evenly and smoothly.
2. Draw the image by scratching through the gum coating with the stylus.
3. Rub asphaltum over surface and allow to dry.
4. Rosin (on stone), talc, and etch.

Method II
1. Cover stone or plate with asphaltum and allow to dry. Be sure the surface is coated evenly and smoothly.
2. Draw the image by scratching through the asphaltum.
3. Rosin (on stone), talc, and etch.

Classic Litho Line Engraving

Although this technique was used extensively in the past, it is seldom employed today. Nevertheless, it is capable of producing the finest and most delicate lines that can possibly be drawn by the lithographic process. Method I will produce negative lines; Method II, positive lines.

10-3 Negative line drawing

Method I

1. Grain the stone with carborundum in the usual way. Do not use a levigator. Special care must be taken with #320 carborundum; because it is so fine, it can cause severe scratches.
2. Continue graining with #320 carborundum for three cycles.
3. Wash off #320 carborundum and sprinkle a small amount of the optical powder onto the surface of the stone without removing the excess water. Grain until a paste begins to form. Then, stop, or severe scratching may occur. Grain with optical powder for three cycles.
4. Stop out the borders of the stone with etching solution (10 drops acid to 1 ounce gum arabic).
5. Rub a liberal amount of asphaltum evenly over the entire surface of the stone and allow to dry.
6. Using a stylus or other sharp instrument, incise drawing through the asphaltum.
7. Rosin and talc.
8. Etch the stone with etching solution (10 drops acid to 1 ounce gum arabic).
9. With a cheesecloth, wipe down and buff dry.
10. Wash out and roll up.
11. Second-etch the stone. This etch should be stronger than the first etch.

Supplies

2 litho stones of similar size
Carborundum (#80, #150, #220, #320)
Optical powder (#5 micron)
Nitric acid
Gum arabic
Asphaltum
Stylus
Cheesecloth
Solution of 1 ounce gum arabic, 6 drops phosphoric acid, 1 teaspoon tannic acid, and a pinch of methyl violet

Method II

1. Grain as described in steps 1 through 3 in Method I.
2. Counteretch the surface of the stone.
3. Spread the gum-phosphoric acid solution onto the surface of the stone, wipe down with a dry cheesecloth, and fan dry.
4. Scratch the drawing through the gum coating.
5. Wipe a liberal amount of asphaltum over the entire surface of the stone and allow to dry.
6. Dissolve the surface film with a wet rag.
7. Roll up.
8. Etch.
9. Wash out, roll up, and dry.
10. Rosin the entire image.
11. Sponge the surface of the stone and roll up over the rosin.
12. Repeat step 11 three times.
13. Second-etch with a strong solution to bring the engraved lines into relief.

PHOTOTRANSFERS

Printed images may be transferred to a stone or plate by this means.

Method

1. Counteretch stone or plate.
2. Attach printed image face down on stone or plate with Contact paper.
3. Brush lacquer thinner sparingly onto the back of the image.
4. Immediately begin to burnish and continue until the image is transferred.
5. Remove printed matter.
6. Rosin and talc.
7. Etch with a diluted gum solution (50 percent gum arabic and 50 percent water). If the gum is not correctly diluted, the image will be burned.
8. Wash out transferred ink.
9. Roll up. *Note:* If the image does not come up strongly enough, apply rosin and continue rolling over the rosined surface to build up the ink layer.
10. Rosin (on stone), talc, and etch.

Supplies

Images from magazines or newspapers (*Note:* The printed matter should be freshly printed to insure a high grease content.)
Contact paper or tape (Contact paper leaves no residue)
Lacquer thinner
Brush
Burnisher
Gum arabic

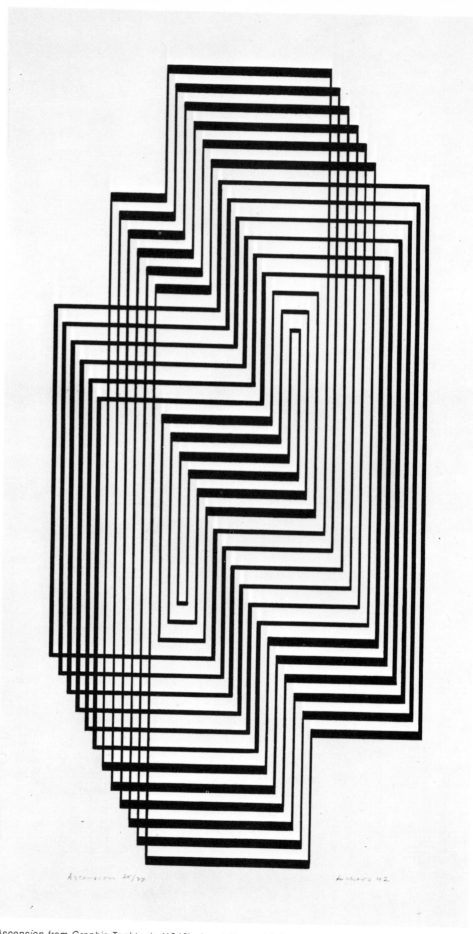

Ascension from Graphic Techtonic (1942), Josef Albers. (Collection, The Museum of Modern Art, New York. Gift of the artist)

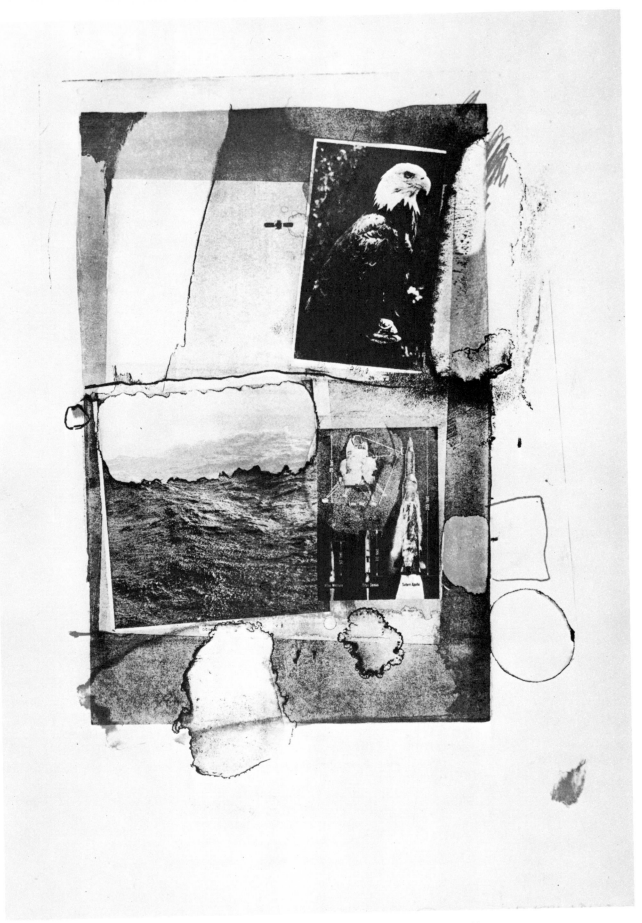

Night Grip (1966), Robert Rauschenberg. (Leo Castelli Gallery, New York. Photo, Rudolph Burckhardt)

10-4 Engraved plate

10-5 Inking an engraving

PHOTOTRANSFERS FROM ENGRAVINGS

Supplies

Metal engravings or Scan-o-gravings
 (Fairchild engravings)
Brayers
Roll-up ink
Burnisher

Method I
1. With a hard brayer, ink engraved metal plate.
2. Roll another brayer (with a circumference larger than the engraved image) across the inked engraving.
3. Reroll the brayer with the image to transfer it onto the stone or plate and allow to dry.
4. Rosin (on stone), talc, and etch.

Method II
1. Proof metal engraving on glossy paper on an etching press.
2. Place proof face down on stone or plate.
3. Roll through press. The pressure will transfer the image from paper to printing surface.
4. Rosin (on stone), talc, and etch.

Method III
1. Use a hard brayer to ink Scan-o-graving. (Because of the flexibility of these plastic plates, the engraving may be transferred directly to the litho stone or plate. Scan-o-gravings transfer most clearly and accurately.)
2. Place the inked side face down on the printing surface and rub with burnisher. The amount of pressure applied determines the intensity of the image.
3. Let the transferred ink dry overnight.
4. Rosin (on stone), talc, and etch.

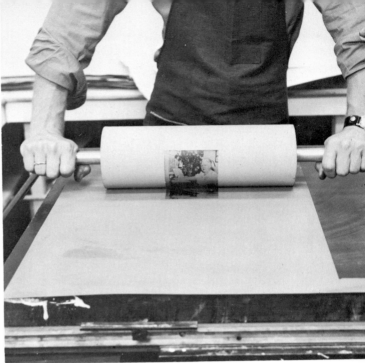

10-6 Engraving offset onto a composition roller

10-7 Rerolling image onto plate

10-8 **Image transferred from Scan-o-graving to surface of plate**

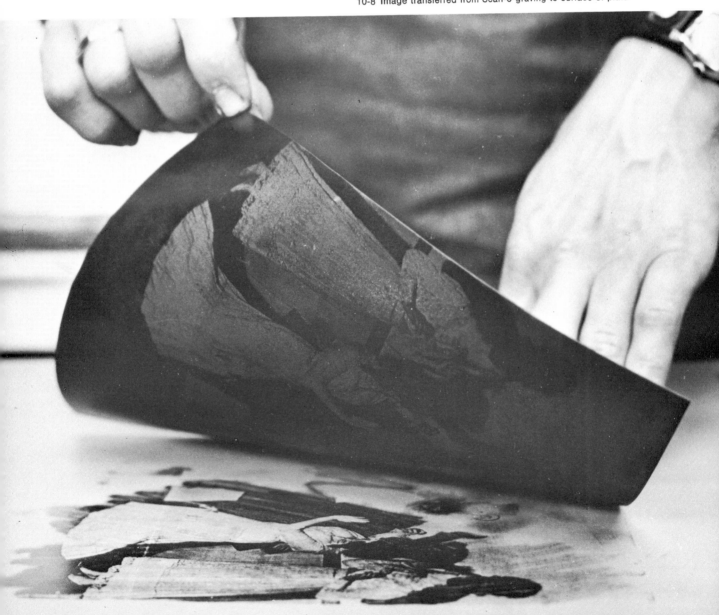

RAINBOW ROLL

A number of colors may be printed at the same time by this technique.

Supplies

Colored inks
Composition roller

Method

1. Place small amounts of different colored inks next to one another at one end of an inking slab. The placement of the inks will determine the amount of color mingling.
2. Roll out the inks with the roller, gradually smoothing them into bands that butt at the edges.
3. When the roller is evenly inked, roll up stone or plate, and proceed to print.

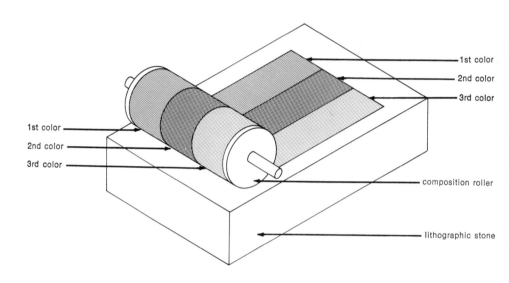

REVERSALS

Reversals may be used to obtain a negative image on the whole surface or on a portion of a stone or plate. If you follow the procedure carefully, the drawing will appear in negative form. The image may be re-reversed to reproduce the positive with little loss in the subtle grey areas. To execute a partial reversal, take a proof on transfer paper and make all deletions on it before transferring the image to the printing surface.

Supplies

Orange shellac
Alcohol
Pan (large enough to rest stone or plate in)
Gasoline
Absorbent cotton

Method I

1. Roll up stone or plate with fresh ink.
2. Rosin (on stone) and talc.
3. Counteretch.
4. Wash off and dry.
5. Prepare a solution of 2 parts shellac to 1 part alcohol. Approximately 4 ounces of solution are needed to coat a stone or plate measuring 18″ by 24″. *Note:* If the solution is too dry, the washing out procedure will be difficult. If it is too wet, sections of the drawing will wash out and some of the image will be lost.
6. Tilt the stone or plate at a 60-degree angle and place a pan at the base for drainage. Starting at the top, pour the shellac-alcohol solution evenly from left to right over the surface. Allow solution to drain into pan.

7. Fan the surface uniformly until dry.
8. Wash out image with cotton soaked in gasoline to remove all traces of ink.
 Note: The surface should appear smeared and unattractive. Do not abrade the surface by applying too much pressure.
9. Etch with a moderately strong solution to remove all traces of grease and to burn out the previous image.
10. Wash off the etch, rub up with asphaltum or ink, fan dry, sponge the surface, and roll up.
11. Rosin (on stone), talc, and second-etch.

Method II (for aluminum plate reversal)

Supplies

Lith-Kem-Ko Lacquer C
Lith-Kem-Ko Lacquer C Solvent or lacquer thinner
Webril Wipes
Liquitex varnish
Kim Wipes
Hanco Tannic Acid Etch

1. Roll up the image with fresh ink.
2. Talc the image.
3. With clean sponge and water, clean the entire plate and image of excess talc.
 Note: If the image had been lacquered, apply a new gum film, wipe down with cheesecloth, allow to set for 5 minutes, and then proceed to wash out the lacquer base using Lacquer C solvent or lacquer thinner. Then rub up with asphaltum, dry, wash off with water, and roll up with ink. Proceed to step 2 above.
 Note: If you desire nonprinting white borders, gum the plate and place contact paper over areas you wish not to print. After the contact paper is in place, wash off the gum with a sponge and dry.
4. Dry.
5. Apply the Liquitex mat varnish with a Webril Wipe over the entire surface.
6. Buff down the varnish gently with a cheesecloth. (Rough buffing will cause streaking.)
7. Dry for approximately 20 minutes.
8. Apply a second coat of varnish.
9. Buff down dry with cheesecloth. (Make sure the entire image area is covered with varnish. This will avoid streaking.)
10. Let dry thoroughly.
11. Wash out the image with turpentine or lithotine. (Rub lightly.)
12. Then repeat using lithotine or turps until it is absolutely clean and free from any grease deposits or dirt.
13. Etch the image areas with 100-percent Tannic Acid etch for approximately 3 minutes.
14. Wash off with water.
15. Gum.
16. Buff-down with cheese cloth.
17. Dry.
18. Wash off the Liquitex varnish with Lacquer thinner or alcohol.
19. Dry.
20. Rub up with asphaltum or Lacquer C.
21. Rub up the Lacquer C with asphaltum.
22. Dry.
23. Wash off with sponge and water and proceed to roll up the newly reversed image.
24. If the negative areas begin to scum, etch with 50-percent Tannic Acid and 50-percent gum arabic.
25. Let it set for 5 to 10 minutes.
26. Wash off the gum and continue to roll-up.
 Note: Extreme fidelity may be achieved by careful wiping down of the varnish. It is possible to achieve finer detail by diluting the varnish with water thus achieving a tighter film.

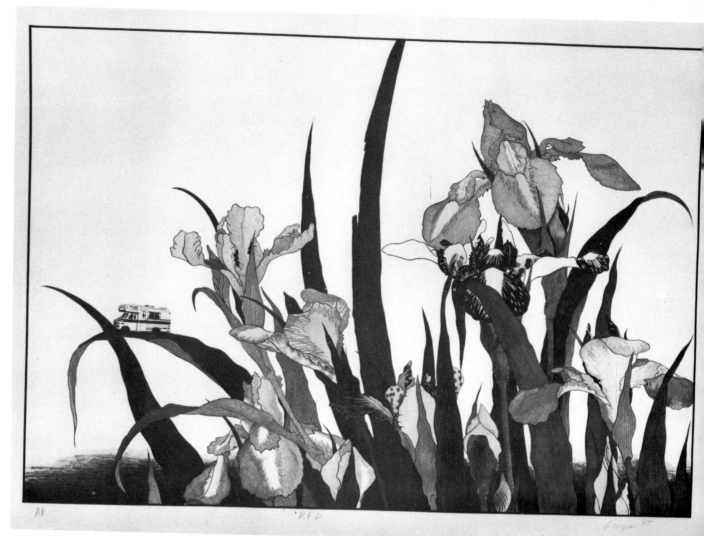

RFDI, (1975), Michael Knigin.

Untitled Lithograph (1965), Nicholas Krushenick. (Pace Editions, Inc., New York)

TEXTURAL EFFECTS

A variety of materials will yield diverse textures in the first method. The second method is a combination of many techniques. Developed by Albert Christ-Janer, whose *Skyforms* is reproduced here, it produces unique textural effects on metal plates.

Supplies

Cardboard, cloth, wire, leaves, or commercial products such as Prestype and stencils
Roll-up ink or tusche
Rubber cement
Chinese white gouache
Newsprint
Paraffin
Crayons, pencils, ball-point pens, or other drawing materials
Clear spray (Krylon)
Lacquer thinner
Razor blade, sandpaper, or other hone

Method I

1. Dip the desired materials into roll-up ink or tusche and press onto stone or plate, or pass an inked roller over stencils for application. *Note:* Be sure to talc surface well to facilitate drying of ink.
2. Rosin (on stone), talc, and etch.

Method II

1. Stop out sections of the plate with rubber cement and thinned gouache.
2. Place plate on newsprint. Apply wax over desired areas.
3. Flow water over sections of plate and add desired amount of tusche to liquid.
4. Begin drawing with crayons or other drawing materials.
5. Allow drawing to dry. Then, areas may be sprayed with clear spray to give an aquatint effect when rolled.
6. Talc and etch.
7. Wash out drawing with lacquer thinner (to insure removal of rubber cement, clear spray, and remainder of drawing).
8. Rub up and proof.
9. Talc.
10. With razor blade or other hone, abrade the surface to produce gradation of tones and to eliminate unwanted areas.
11. Second-etch.

TONAL GRADATIONS

Supplies

Airbrush or toothbrush
Tusche, autographic and zincographic ink

Method

Use airbrush or toothbrush saturated with tusche or ink to spray a fine film on stone or plate. A frisket or stencil may be used to mask out various areas.

TRANSPARENT OVERLAY (TONE PLATE)

This technique involves placing a transparent color over a previously printed surface. By using a gum stopout on sections of a second stone or plate used for the tone, the areas to be covered by the transparent overlay may be easily delineated.

Supplies

Gum arabic
Nitric acid or Hanco Acidified gum etch
Asphaltum

Method

1. Trace original drawing or a portion of it onto new stone or plate. Be sure the tracing is exact to avoid registration problems.
2. Cover traced areas evenly with gum etch (for stone, 10 drops acid to 1 ounce gum; for plate, 50 percent Hanco Acidified gum etch and 50 percent gum). *Note:* The areas stopped with gum will *not* be toned.
3. Dry.
4. Rub asphaltum over entire surface and allow to dry.
5. Wash with water to release gum.
6. Roll up.

VIBRATION EFFECTS

Vibration effects are obtained by overprinting and off-registering an image.

Method
1. Print an edition using register marks and allow to dry.
2. Decide on non-vibration areas and delete from original stone or plate. For stone, delete by scraping with abrasive; for plate, wash areas to be deleted with lacquer thinner and paint with lye or rub on 3M solution with cotton swab and dry. *Note:* Lye can cause severe burns if handled carelessly. Rubber gloves should be worn.
3. For stone, etch to remove remaining residue. For plate treated with 3M solution, etch; omit this step if lye is used, since it will act as an etch.
4. Roll up stone or plate with second color.
5. Print second color, moving register marks left or right, up or down to off-register the image.

Supplies

Razor blade, snake slip stone, or rubber hone
Lacquer thinner
Lye or 3M plate cleaner and conditioner
Absorbent cotton
Rubber gloves

Skyforms, Albert Christ-Janer. (Courtesy of Chiron Press. Photo, Jeffrey Loubet)

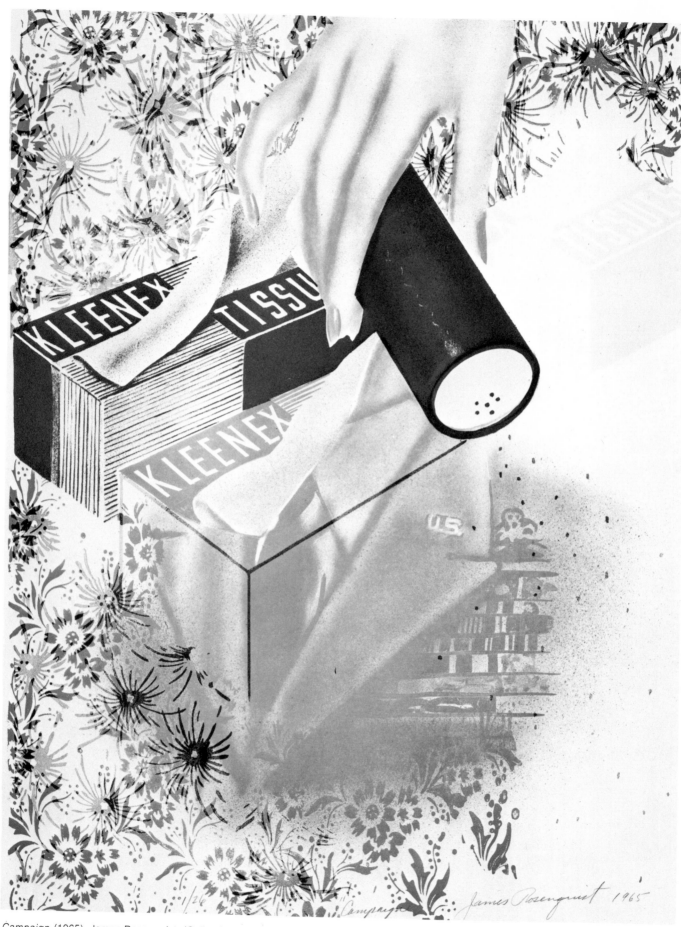

Campaign (1965), James Rosenquist. (Collection, The Museum of Modern Art, New York. Celeste and Armand Bartos Fund)

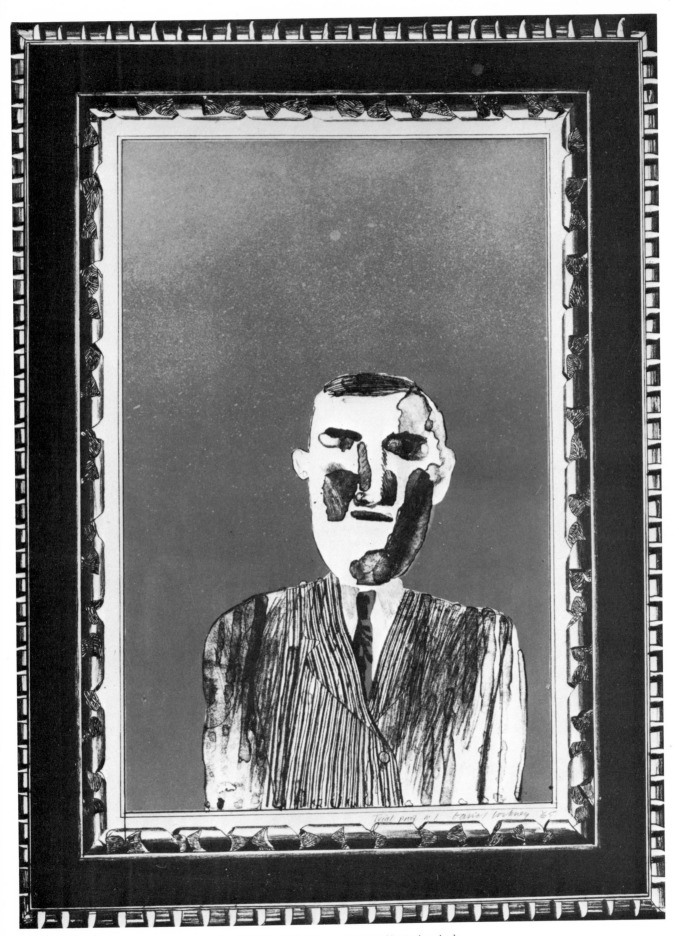

Picture of a Framed Portrait (Hollywood Collection), David Hockney. (Editions Alecto, London)

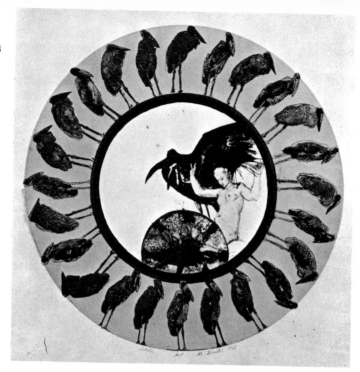

Stork, Murray Zimiles. 1968

PRINTING ON NON-ABSORBENT SURFACES

A variety of new materials which have non-absorbent surfaces—mylar, acetate, plexiglass, coated papers, etc.—have become part of the vocabulary of the contemporary lithographer.

When using non-absorbent materials, be sure that they are entirely clean and free of lint by using the various cleaners and brushes which are available from most plastic-supply houses.

Because these materials are non-absorbent, the following modifications in procedure must be made. First, lighten the pressure to prevent ink seepage beyond the confines of the drawing. Next, adjust the ink as necessary to conform to the particular material being used. Finally, dry the prints in a drying rack that can be covered to prevent lint and dirt from adhering to the ink surface. A long drying period will be needed.

COMBINATION PRINTS

Intaglios, serigraphs, and other graphic techniques may be combined with lithographs to produce interesting results. The important thing to remember when making combination prints is the sequence of printing. Intaglio printing requires soaking the paper; hence it is advisable to place it over the lithograph, retaining the embossed effect.

Silk-screen printing can be done before or after lithographic printing with little difficulty. Here the opacity or transparency of the inks used in both techniques will play an important role in creating the final effect. Murray Zimiles's *Stork* was first printed by the lithographic process and allowed to dry. Then it was screened with a highly transparent pink dye and blotted twice by running it through the lithographic press with a sheet of newsprint, which mopped the surface and increased the transparency of the color.

Lithography may also be combined with embossing. After the colors have been printed and allowed to dry, soak the paper, and, with careful registration, run a second plate of high relief through an etching press to emboss the print.

Photolithography

Artists often incorporate photographic images in their prints, and various techniques for transferring printed images to a stone or plate are discussed in Chapter 10. However, in order to reproduce original copy containing tonal gradations, the halftone process is used. Photo-litho plates and stones require negatives of extreme high contrast, that is one composed of opaque and transparent areas only. This is done by placing a halftone screen over the film (Ortho Type 2 or Ortho Type 3 film no. 4556) in the camera while the copy is photographed. During the exposure, reflected light from the copy passes through the lens and the tiny openings in the halftone screen onto the film. The image formed on the film emulsion consists of dots or other shapes depending on what type of halftone screen is used. Each opening in the screen acts as a tiny lens producing one dot on the film emulsion. The darkest areas on the copy reflect the least therefore they produce tiny opaque dots on the film emulsion. Tonal areas of the copy translate into a checkerboard effect of opaque and transparent squares. The sizes of these squares vary depending on the lightness or darkness of the copy. The lightest areas of the copy produce heavy opaque areas with tiny transparent dots. What is important here is that the developed Ortho film will either be transparent or opaque. Thus when used to shoot a photo plate or stone, light of equal strength will pass through the film solidifying the photo emulsion on the plate (or stone) producing a surface that is strong and capable of withstanding the pressures of rolling and printing.

HALFTONE SCREENS

Numerous types of halftone screens are available. Most are very expensive. The two types most commonly used are glass and contact screens. Two sheets of glass are etched with parallel lines. These etched lines are filled with opaque-light blocking material. The two are then glued face to face with the lines of one intersecting the lines of the other at 90 degrees. Contact screens are made of flexible plastic. They are used in direct contact with the film. The emulsion side (dull side) of the screen touches the emulsion side of the film.

Dot screens come in various sizes. The higher the number, the finer the screen. However, in hand lithography screens finer than 150 line should not be used.

Halftone screens are very expensive. In recent years products like Zipatone have been substituted. Zipatone is a dot, line, aquatint, or patterned, opaque image on a transparent plastic sheet used by graphic designers and architects. The dots, lines, etc., produced by substituting this for a dot screen are less sharp. However, in a fine art lithograph this could be an advantage. The chief reason for the substitution is varieties of effects and cost. The Zipatone costs are 100 times less than dot sheets.

SEPARATING COLOR COPY

Color printing requires a separate plate for each color. By using four (more or less can be used) colors—yellow, red, blue, and black—a reasonable facsimile of the copy can be made. These colors are separated out from the original copy by the use of filters, or specifically prepared films that are sensitive to a single color. A violet filter will separate out the yellow for the negative while a green filter provides the red. An orange filter, the blue and a yellow filter, the black. When color separating, it is necessary to change the screen angle for each negative so that the dots don't overlap. The angles most often used are 90 degrees for yellow, 75 degrees for red, 15 degrees for blue and 45 degrees for black.

MAKING A HALFTONE NEGATIVE AND USING THE COPY CAMERA

Without using photographic procedures, a simple negative can be made by drawing on a sheet of mylar or acetate. The only requirement is that the drawing be opaque. The drawing is placed over the film (contacted) and then exposed. No halftone screen is necessary. However, if the drawing contains tonal gradations, it is imperative to use a halftone screen to obtain a true reproduction on the film. The most popularly used film for making line shots, halftones, or positives is Kodak Ortho Type 2 or Ortho Type 3.

Supplies

for nonphotographic positive or
 negative:
acetate or mylar
any ink that will make an opaque image

for photographic positive:
Kodak Ortho Type 2 or Ortho Type 3 film
A and B developer solution
stop bath
fixing solution

Method
The following procedure is usually done in the copy camera.
1. Place the copy on the center of the copy board. Be sure that the glass is clean on both sides. Close and flip the board into the vertical position facing the lens.
2. Most copy cameras have tapes that are used for aligning the camera lens with the copy board. Numbers on the board allow you to either enlarge or reduce the copy. This can also be done by the use of ground glass. To change the scale of an image seen on the ground glass move the copy board. To focus the image move the bellows. Use the ground glass to check for hot spots. If there are any hot spots visible, change the angles of the lights.
3. Cap the lens and remove the ground glass by flipping it out of the way.
4. Calculate the exposure time (f-stop). In determining the exposure time various guides such as density guides may be used. The best method is to do tests. Tests are made by placing a strip of opaque paper over the film. Expose for 5 seconds. Move the paper a few inches and expose for another 5 seconds. This is called an exposure step test guide. Continue this until you are satisfied that you have covered the gamut of exposure times.
5. In the darkroom using the proper safelight for the type of film you are using (for example: a Wratten Series 1A red safelight is used with Ortho Type 2 film). Prepare to load the film. The boxes of film usually contain information for the type of safelights to be used in conjunction with that specific type of film. Cut the film to the desired size. *Note:* When loading the film on the vacuum board, make sure the emulsion side of the film is facing the lens. The emulsion side is the grey lighter side. Ortho film is sensitive to yellow safelights. DO NOT USE.
6. Place the dot, line, or mezzotint, etc., screen over the film. The dot screen should be larger than the film. This enables the vacuum to hold it perfectly flat against the film and camera back. Apply the vacuum.
7. Expose.

8. With the vacuum still on, open the back of the camera and expose to a flashing lamp. The flashing light is a Kodak Safelight Filter, Wratten Series 00. It is a 7½ watt frosted lamp 6 to 8 feet from the camera back. This will improve the film contrast. Once again to determine the proper flashing time a test strip should be used. This entire procedure is optional in hand litho work. For offset press work it is necessary.
9. Develop the film in the darkroom. Use the appropriate developer. For Ortho Type 2 film, develop in A and B solution. Prepare each by dissolving the powder in water. Store separately. When using as a developer, mix equal parts of A and B into a tray. *Note:* A well developed negative should have a clear transparent image against a black opaque background.

From the developer place the negative into the stop bath for 30 seconds. *Note:* Stop bath is a mixture of 1 ounce acetic acid to 16 ounces of water. Remove and place the negative into the fixing solution for approximately 15 minutes. Here all traces of the milky solution on the emulsion side should disappear. Remove from the fix and place in a tray of running water at 68 degrees F., for about an hour.

Remove, squeegee the surface, and hang it up to dry in a box of warm circulating air. This type of drying box can be made as follows. Construct a box of plywood. The box size should be large enough to hold the largest size of negative that you will use. Attach wires to the top of the box on which the film, held by clips or clothes pins can be attached. Cut a hole in the side. Place the nozzle of a hair dryer in the hole. This will supply the heat and warm circulating air.

A positive transparency can be made from a negative transparency by utilizing the contact method. Using the back of the vacuum chamber of the copy camera simply place a piece of the same Ortho film under the negative. To ensure good contact, cover the film and negative with a piece of glass. Expose for about 30 seconds under a yellow light. Remove the film and develop as above. Many shops are equipped with a contact frame and it can also be used to make a positive transparency.

Note: A copy camera or contact frame need not be used. A regular enlarger could substitute. By placing a negative in the negative holder and dot screen between it and a piece of Ortho Type 2 film, a halftone negative can be made. If the halftone negative is small it can then be placed in the enlarger and shot directly onto another piece of Kodalith. Needless to say, the larger the blow-up, the larger the dot pattern will be.

MAKING THE PHOTOGRAPHIC PLATE OR STONE

Pre-sensitized litho plates may be substituted for the ST plate and process described below. These plates arrive from the factory coated with a light sensitive surface. They should be exposed in a similar manner as the ST Plates. Follow the instructions that come with the plates. They will contain processing information.

The ST process described below utilizes a very simple contact method. Today, numerous plate-making machines, many with vacuum frames, are available. Needless to say, these machines enhance contact between the negative and the plate.

ST PROCESS

The ST process explained here, is a simple method for shooting photographs directly onto the lithographic plate. Supplies comparable to the ST materials are available under different brand names in different parts of the United States and elsewhere.

Supplies

ST plates
ST Super-D Powder
ST Base Solution
ST Wipes
Super-D Developer
DuPont Cellulose Sponge (Standard)
Absorbent cotton
Super-D A.G.E.
#2 photo bulb and reflector
Cheesecloth
Soft rags

Method

1. Prepare the coating solution by adding all the ST Super-D Powder to the Base Solution. Shake vigorously until the powder is dissolved. The solution will keep for a week at normal room temperature.
2. ST Plates, or any ball-grained plates that are suitable for hand lithography, are ready for use and do not require any treatment prior to coating. Care should be taken when handling the plates to avoid smudges or fingerprints, which may reproduce. Place the plate on a table protected by waste sheets somewhat larger than the plate. Pour a small amount of the coating solution on the plate and spread evenly with ST Wipes. (Other wipes may produce lint, which can cause pinholes or other damage.) Use alternating wiping strokes—from side to side, then up and down—to coat the plate smoothly and uniformly. *Note:* The operation must be performed in subdued light (yellow or gold fluorescent lights are recommended), and plates should be coated, exposed, and finished the same day.
3. Dry thoroughly with fresh ST Wipes.
4. The ST Plate should be exposed for approximately five to ten minutes with a #2 photo bulb with reflector about 18″ above the plate (see Figure 11-1). *Note:* These specifications may vary, depending on the particular work. You will arrive at the proper exposure times through experience.
5. Shake the Super-D Developer well. Pour a sufficient amount onto the plate, and work it over the entire area with a damp sponge. When the plate is completely developed, the image will be intense.
6. Rinse off excess developer and complete cleaning with a cotton swab under running water. Drain off excess water by tilting plate. Do not squeegee.
7. Pour a sufficient amount of Super-D A.G.E. on the wet plate and rub over entire plate with damp sponge, giving special attention to the image area. This will give the image area an extremely water-repellent surface.
8. Add a little more A.G.E., spread with damp cheesecloth, and dry with a soft cloth.
9. Sponge with water, roll up, and print.

11-1 Exposing the ST Plate

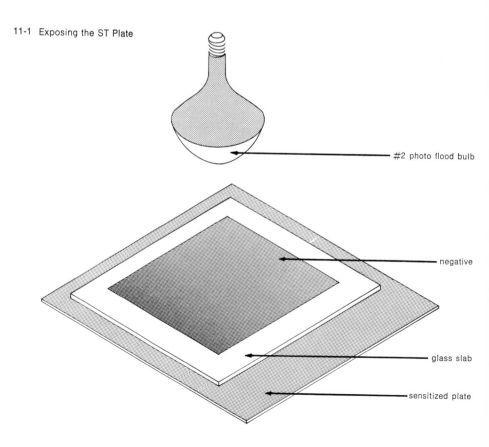

#2 photo flood bulb

negative

glass slab

sensitized plate

ST PROCESS ON STONE

The following method allows for photographic reproduction and/or photographic reproduction combined with drawn images. For photographic reproduction only follow the ST process described above. For photographic reproduction combined with drawn images proceed as follows.

Supplies for ST Process on Stone

Conté crayon
Clear contact paper
Stone counter-etch
Rosin talc
ST supplies (see above)

Method

1. Using Conté crayon delineate the area on the stone that will contain the photographic image.
2. Using a solution of gum arabic with 10 drops of nitric acid paint out every part of the stone except the area delineated by the Conté crayon.
3. Buff down the etch. Be careful not to get any of the etch into the Conté crayon delineated area.
4. Affix clear contact paper over the entire stone.
5. Cut-out the area that will house the photo image (the Conté crayon delineated area).
6. Proceed coating the photo area with the ST solution as described in the ST Process.
7. Continue the entire ST Process as described above.
8. Remove the contact paper after Step 8 in the ST Process.
9. Sponge with water and roll-up the image.
10. Rosin and talc.
11. Counter-etch the entire stone.
12. Draw.
13. Etch according to the stone etch table. The photo area need only be gummed.

Note: It is possible to draw within the photo area by either honing out areas or by painting directly with Lacquer C over areas.

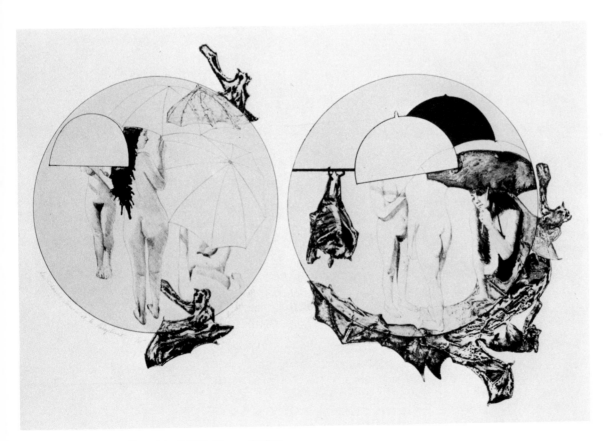

Le Chauve Souris et le Parapluie, (1973), Murray Zimiles.

COMMON LITHOGRAPHIC PROBLEMS AND HOW TO CORRECT THEM

Problem	Cause	Remedy
Bleeding of image.	Too much varnish in certain types of ink (Thalo Blue, Red, and Green and Permanent Rose Red).	Stiffen ink with magnesium carbonate and use a fountain solution.
Color registration faulty during proofing.	Incorrect placement of register marks.	Pull proof of last image or of dominant image on acetate. Be sure to include register marks. Check by overlaying acetate on other plates and adjust incorrect marks.
Crackling and peeling of gum on printing surface.	Gum coating too heavy and uneven.	Wash off old gum. Regum. Wash out, roll up, and regum. Wipe down evenly with dry cheesecloth.
Filling in and darkening of image.	Too much ink.	Wash slab and roll out ink on roller. If image still fills in, scrape roller.
	Too much extender in ink.	Stiffen ink by adding magnesium carbonate and roll rapidly. If problem persists, alternately beat stone or plate with a sponge saturated with gum and roll rapidly across the image.
	Weak etch.	Rosin (on stone), talc, and re-etch (increased strength).
	Breakdown in gum coating.	Talc and regum.
	Excessive pressure.	Reduce pressure.
Irregular patterns on unused plate.	Oxidation.	Counteretch.
	Paper unevenly dampened.	Soak sponge and dampen uniformly, covering the entire sheet of paper.
Light image.	Uneven rolling.	Roll smoothly from all directions in specified rolling pattern.
	Ink too stiff.	Add extender to ink.
	Highly textured paper.	Change to appropriate paper.
	Not enough pressure.	Increase pressure.
	Hollow stone.	Add paper between wood and leather of scraper bar in hollow areas.
	Burned image.	Counteretch and redraw.
	Improper washout.	Rosin (on stone), talc, and gum; repeat washout, and roll up. The use of asphaltum in rubbing up an image is a general remedy for slightly intensifying a light image.
Marks appearing in image.	Faulty tympan or embossed blotter.	Replace tympan and/or blotter.
Non-adherence of overprinted color.	Ink too thick or too dry.	Add varnish or Setswell Reducing Compound to ink.
Offsetting of second color onto stone or plate.	Prints not fully dry.	Allow prints to dry before running second color or wet the stone or plate before printing or dust magnesium carbonate over print.
Reappearance of image in deleted areas.	Improper erasure.	Delete again and spot-etch.
Roller marks.	Damaged or uneven roller.	Resurface or replace roller.
	Improper rolling.	Follow rolling pattern and use feathering.
	Ink too stiff.	On stones, add #470 reducing oil. On plates, add #00 varnish to ink.
	Dry ink particles or dust in ink	Remove particles and reroll. If severe, clean ink slab and scrape roller.

Problem	Cause	Remedy
Scratches in circular form on image and stone.	Improper graining.	Regrain with #80 carborundum until scratches are removed. Continue graining with finer carborundum until desired surface is reached.
Scumming	Too much extender in ink.	Add more ink or add magnesium carbonate to stiffen ink.
	Contaminated roller.	Scrape roller well and add fresh ink.
	Grease or dirt on stone or plate.	Regum by beating the stone or plate with sponge saturated with gum. If problem persists, for stone, rub dirty areas with saturated solution of calcium carbonate and gum, and re-etch. For plate, talc, then clean with solution of calcium carbonate, gum, and gum etch.
	Solvent on stone or plate.	Check edges underneath stone or plate for deposits of solvent, change water, and wash sponges thoroughly.
	Reducing oil added to ink (with metal plates).	Mix new batch of ink using varnish.
	Underetched stone or plate.	Roll up, rosin (on stone), talc, and re-etch.
	Breakdown of gum coating due to excessive pressure or dirt in the ink, or excessive abrasion of printing surface.	Rosin (on stone), talc, and regum.
Shine on dry printed surface.	Too much varnish in ink.	Add magnesium carbonate or Setswell Reducing Compound to ink.
Sliding of paper on solid areas.	Too much ink.	Reduce amount of ink.
	Ink too soft.	Add magnesium carbonate and/or Setswell Reducing Compound.
Slippage of stone or plate on press bed.	Too much water under stone or plate.	Raise stone or plate and wipe back and press bed.
	No suction.	Redampen with clean water.
	No bracing of stone or plate.	Brace with wooden planks at rear of press bed.
White bands extending vertically through image.	Faulty scraper bar.	Check leather and renovate or change scraper bar.

GLOSSARY OF CHEMICALS AND COMMERCIAL LITHOGRAPHIC PRODUCTS

* An asterisk denotes chemicals that are dangerous and should be handled with care.

CHEMICAL OR PRODUCT	USE
Alcohol	Leather roller reconditioning
	Reversals, total or partial
	Textural wash effects created by combination with liquid tusche
Alcohol, Anhydrous	Lacquering metal plates for long runs
*Alcohol, Isopropyl	Etching zinc plates
Alum	Counteretching zinc plates

CHEMICAL OR PRODUCT	USE
Ammonium Bichromate (Photo Grade)	Counteretching aluminum plates
Asphaltum	Burning with acid to remove all or part of an image
	Lacquering metal plates for long runs
	Line drawings on stone or plate, scratching technique, and classical litho line engraving
	Rub up
	Rub up of plate or stone for temporary storage pending completion of color run
	Photolithography
	Transparent overlay (tone plate) technique
*Benzine	Corrections and deletions on metal plates
Calcium Carbonate	Cleaning zinc plates
*Carbolic Acid	Removal of image from stone or plate
Gasoline	Removal of image from stone or plate
	Cleansing stored leather roller prior to re-use
	Reversals, total or partial
Glacial Acetic Acid	Counteretch solution to allow additions on stone
Hanco Cellulose	Cleaning, gumming, and etching zinc plates
Gum Etch (Acidified) MS #571	Corrections and deletions on metal plates
	Etching zinc plates
	Transparent overlay technique
Harris Aluminum Plate Counteretch	Counteretching aluminum plates
Harris Alum-O-Lith Plate Conditioner	Cleaning aluminum plates
Harris Commercial Counteretch	Counteretching zinc plates
Harris Non-Tox Fountain Solution	Cleaning stone during printing
*Hydrochloric Acid	Counteretching zinc plates
*Hydrofluoric Acid	Counteretching aluminum plates
Imperial Fountain Solution	Cleaning stone during printing
Lacquer Thinner	Corrections and deletions on metal plates
	Phototransfers from printed matter
	Textural effects created by combination with liquid tusche
	Vibration effects technique
Lighter Fluid	Textural effects created by combination with liquid tusche

CHEMICAL OR PRODUCT	USE
Lith-Kem-Ko Deep-Etch Lacquer C	Lacquering metal plates for long runs
Lithotine	Etching zinc plates Washout and rub up
Lithpaco Plate Cleaner	Corrections and deletions on metal plates
*Lye	Deletions from metal plates Regraining metal plates Vibration effects technique
Magnesium Carbonate	Printing ink stiffener
Magnesium Nitrate	Etching zinc plates
*Nitric Acid	Classic litho line engraving Corrections and deletions on stone Counteretching zinc plates Etching stone Transparent overlay (tone plate) technique
Oxalic Acid (diluted)	Regraining metal plates
Paint Remover	Leather roller reconditioning
*Phenol	Removal of image from stone
*Phosphoric Acid	Classic litho line engraving Etching zinc plates
Pitman Uniclean Etch	Etching aluminum plates
Setswell Reducing Compound	Printing ink additive
Sinclair and Valentine Reducing Oil No. 470	Printing ink additive
ST Products	Photolithography
Tannic Acid	Etch for aluminum plates
3M Brand Cleaner Conditioner	Corrections and deletions on metal plates Creation of vibration effects
Turpentine	Etching and roll up for fragile drawings Etching zinc plates Special wash effects created by combination with litho crayons and pencils Textural effects created by combination with tusche Washout and rub up

GLOSSARY

Abrasion—Removal of all or part of a drawing by exerting friction on the surface of a stone or plate.

Absorption—The penetration of a substance into the pores of a stone.

Additives—Substances mixed with printing inks to obtain special qualities.

Adsorption—The creation of an insoluble surface film which clings to the non-printing areas and the interstices of the grain of a stone or plate.

Autographic Ink—A viscous, highly greasy substance used to create solid areas on a stone or plate.

Baumé Scale—Measure of viscosity.

Benelux—A pressed hard wood used in the making of scraper bars.

Ben-Day Medium—A transparent acetate with mechanical dot patterns for the creation of tints or halftones.

Bleeding—The spreading or seepage of ink beyond the confines of a drawing on one or more sides.

Bleed Print—A print that has no margin on one or more sides.

Blotter—Heavy blotting paper used to distribute pressure from the scraper bar in printing.

Brayer—A small hand roller.

Burning—Destruction of grain or drawing material or ink by excess acid.

Burnisher—A polishing tool for transferring techniques.

Carborundum—A powdered abrasive used in graining.

Caustic Removal—The use of acid to lighten or delete an area.

Chemical Removal—The use of various solvents to lighten or delete areas of a drawing.

Clogging—The filling in of an image.

Composition Roller—Roller, usually made from rubber or glycerin-based compounds, used in color printing.

Counteretch—A solution that cleans or resensitizes a stone or plate to receive an image.

Cracking—An effect caused by the drying of a heavy gum film on the surface of a stone or plate, undesirable except when used as a special effect.

Cuffs—Protective pieces of leather placed on the handles of a roller to prevent burning of the hands.

Deckle—The irregular edge of handmade paper formed by the seepage of the fibrous liquid under the edges of the mold frame.

Desensitizing—The treatment of non-drawn areas to make them ink-repellent and water-receptive.

Driers—Substances added to ink to hasten the drying process.

Edition—The total number of impressions printed from a stone or plate.

Effervescence—Bubbling that occurs when gum-etch hits the surface of a stone.

Etch—An acidic solution that desensitizes the non-drawn areas of a stone or plate.

Extender—A transparent substance that alters the transparency of ink without affecting its color. Extender also increases the covering power of ink.

Feathering—Lifting up the roller during inking to prevent repetition of the image and roller marks.

Fountain Solution—An acid, water, and gum mixture which prevents non-printing areas from accepting ink.

Frisket—A stencil which masks out sections of a plate or stone.

Frottage—Surface rubbing.

Gauge—Numerical evaluation of the thickness of metal.

Ghost—The reappearance of a previous image after the graining or etching of a stone or plate has taken place.

Grain—A surface texture imposed on a stone or plate.

Graphite Paper—A graphite-coated paper used for transferring images.

Gum Etch—A solution of gum and acid used in etching stones and plates.

Halftone—An image composed of different-sized dots, producing tonal gradations.

Hydrophilic—The property of being receptive to water.

Levigator—A steel disc used in stone graining.

Lightfastness—The resistance of material to fading when exposed to light.

Metallic Inks—Inks used to obtain gold and silver effects, usually made from metallic powders of aluminum and bronze.

Negative Areas—Non-printing areas.

Offset Printing—A commercial printing method in which ink is transferred from the plate to a rubber blanket and then to the paper.

Offsetting—Transference of an image from one surface to another.

Oleophilic—The property of being receptive to grease.

Optical Powder—A very fine abrasive used in the graining process.

Oxidation—The chemical union of oxygen with another substance.

Paraffin—A waxy substance with a high grease content.

Peau de Crapeau—A "toadskin" effect obtained by placing a water-tusche wash on the surface of a zinc plate.

pH—The degree of acidity or alkalinity measured on a scale from 0 to 14, with 7 as the neutral point. Values below 7 are acidic; above, alkaline.

Phenolic Resin—A synthetic resin coating, combined with linen to produce an excellent tympan.

Phototransfer—The transference of a photographic image to another surface.

Pigment—Coloring matter in powder form.

Piling—Ink build-up on rollers or plates.

Pinpoint Registration—A registration technique.

Pumice Stone—A very porous volcanic stone that is fine and gritty, used for cleaning and polishing stones.

Push—Paper slippage on a stone or plate.

Reducers—Waxy or greasy compounds used to thin ink consistency.

Register Marks—Marks drawn on printing paper and stone or plate to facilitate registration.

Registration—Correct placement of an image with respect to the paper or a previously printed image.

Retarder—A substance added to ink to slow the drying rate.

Reversal—The changing of negative areas into positive areas on all or a portion of a stone or plate.

Roll Up—To bring up an image with ink using a roller.

Roller Marks—Marks that appear on the surface of the plate or print due to improper rolling techniques.

Rubber Hone—A hard rubber eraser used for cleaning or deleting areas on a stone or plate.

Rub Up—To place a grease film over an image to protect it from burning and to ease rolling.

Scan-O-Graving—Engraved plastic printing plate.

Scotch Stone—An abrasive used for deleting images from stones.

Scraper Bar—A pressure applicator used in printing.

Scumming—The undesirable adhesion of separated ink particles to the plate or stone.

Slip Sheet—Sheet placed between drying prints to prevent the off-setting of the image.

Snake Slip Stone (Water-of-Ayr Stone)—A soft, close-textured stone used as an abrasive for the removal of unwanted areas on a stone.

Solvent—A substance, usually in liquid form, capable of dissolving another.

Spot-etching—The etching of small areas.

Stopout—A masking substance used to prevent inking or etching within a specific area.

Stylus—A sharp-pointed implement used for scratching and scraping.

Tack—A measurement of cohesiveness, as of an ink film.

Tallow—A pure fat used in the reconditioning of rollers.

Tonal Gradation—The range of values from light to dark.

Tone Plate—See Transparent Overlay.

Transfer Paper—A specially coated paper used to transfer a drawing to a stone or plate.

Transparent Overlay—A thin, transparent coating of ink that has been printed over another image.

Trapping—The property of a printing ink which allows it to accept a succeeding ink film.

Tusche—A greasy drawing material.

Tympan—A smooth flat sheet placed between the blotter and the scraper bar on the printing press.

Vehicle—The liquid part of an ink, which carries the pigment and, when dry, binds an ink to the surface upon which it is printed.

Viscosity—The ease of flow of a liquid.

Wash Out—To remove old ink or drawing from a stone or plate.

Watermark—An emblem or other symbol in paper formed by weaving a pattern into the mold wires.

Zincographic Ink—A highly greasy substance with low viscosity used to create solid areas and lines on a stone or plate.

LIST OF SUPPLIERS

GENERAL LITHO SUPPLIERS

Ain Plastics
65 4th Avenue
New York, New York, 10004
(G-10 epoxy sheets for tympans)

Amalgamated Graining Corp.
35-57 9th Street
Long Island City, New York 11106
(zinc plates—graining)

A & E Plastik Pak Co.
8th & Alameda
Los Angeles, California
(print presentation envelopes)

Harry J. Anderson
5851 Leona Street
Oakland, California 94605
(litho stones)

Asbeka Asbestos Corp.
2324 McDonald Avenue
Brooklyn, New York 11224
(Benelux press beds)

Ball Trading Corp.
266 Freeman Street
Brooklyn, New York 11222
(absorbent rags)

Big Joe Sales and Service
29 Cain Drive
Plainview, New York 11803
(hydraulic lifts)

Charles Brand
84 East 10th Street
New York, New York 10003
(litho presses, rollers,
Benelux scraper bars, levigators,
rubber blankets)

Cadillac Plastic & Chemical Co.
Division Dayco Corp.
2305 Beverly Boulevard
Los Angeles, California 90057
(plastic tympans)

California Ink Co.
501 15th Street
San Francisco, California 94103
(litho plates)

Canal Equipment Co.
345 Canal Street
New York, New York 10013
(phenolic resin tympans)

F. Charbonnel
13, Quai de Montebello
and Rue de l'Hotel Colbert
Paris 52, France
(inks, tusche, zincographic
and autographic ink, transfer paper)

Craftools Inc.
1 Industrial Road
Wood-Ridge, New Jersey 07072

Flax Bros.
25 East 28th Street
New York, New York 10016

10852 Lynbrook Drive
Los Angeles, California
(transfer paper, Charbonnel inks and supplies
in the United States)

Graphic Arts Technical Foundation
4615 Forbes Avenue
Pittsburgh, Pennsylvania 15213
(technical books on lithography)

Graphic Chemical & Ink Co.
P.O. Box 27
Villa Park, Illinois 60181
(stones, litho supplies)

King & Malcom Co., Inc.
57-10 Grand Avenue
Maspeth, New York 11378
(carborundum for stone graining)

Koh-I-Noor
Bloomsbury, New Jersey 08804
(Rapidograph pens)

William Korn, Inc.
260 West Street
New York, New York 10013
(tusche, pencils, crayons,
autographic ink)

La Favorite Tusche-Specialité
Ste. des Encres Francaises D'Imprimerie
Vitry-sur-Seine, France
(tusche)

New York Central Supply
62 Third Avenue
New York, New York 10003
(all litho materials)

Premier Graining Co., Inc.
2440 South Prairie Avenue
Chicago, Illinois 60616
(zinc plates, graining)

Rembrandt Graphic Arts Co., Inc.
Stockton, New Jersey 08559
(litho stones and supplies)

Seibold Ink Co.
150 Varick Street
New York, New York 10013
(scraper bar leather,
sponges, cheesecloth)

Spink & Gaborc
26 East 13th Street
New York, New York 10013
(portfolios, print boxes)

Hunter Penrose, Ltd.
109 Farrington Road
London EC 1, England

Charles Schmautz
219, Rue Raymond Losserand
Paris XIV, France

N. Teittlebaum Sons, Inc.
1080 Brook Avenue
Box 444
Bronx, New York 10451

LITHO PRESSES

American Graphic Arts, Inc.
628-642 West 15th Street
New York, New York 10011

Charles Brand
82 East 10th Street
New York, New York 10003

Craftools, Inc.
1 Industrial Road
Wood-Ridge, New Jersey 07072

Dickerson Combination Press
2034 North Mohawk Street
Chicago, Illinois 60614

West Waubun Drive
Fontana, Wisconsin 53125

Graphic Chemical & Ink Co., Inc.
P.O. Box 27
Villa Park, Illinois 60181

LITHO ROLLERS

Brinkman Instrument Co.
Cantiaque Road
Westbury, New York 11590
(PH indicator sticks)

Bumpodo Co.
21, 1-Chome Jimboch-o
Kanda
Chiyoda-Ku
Tokyo, Japan

Charles Brand
82 East 19th Street
New York, New York 10013
(rubber rollers)

California Ink Co.
501 15th Street
San Francisco, California 94103

Craftools, Inc.
1 Industrial Road
Wood-Ridge, New Jersey 07072
(brayers)

Fox Graphics
Back Bay Annex
P.O. Box 328
Boston, Massachusetts 02117
(Levigators)

Graphic Chemical & Ink Co., Inc.
P.O. Box 27
Villa Park, Illinois 60181

Ideal Roller Co.
W. R. Grace & Co.
33 Hayes Memorial Drive
Marlboro, Massachusetts 01752

2512 West 24th Street
Chicago, Illinois 60608
(composition and rubber rollers)

Roberts & Porter, Inc.
4140 West Victorial Avenue
Chicago, Illinois 60646
(leather rollers)

Seibold Ink Corp.
150 Varick Street
New York, New York 10013
(leather rollers)

CHEMICAL SUPPLY HOUSES

Amalgamated Graining Corp.
35-57 9th Street
Long Island City, New York 11106

Automatic Litho Supply Co.
1401 South 3rd Street
Minneapolis, Minnesota 55401

California Ink Co.
501 15th Street
San Francisco, California 94103

Philip Hunt Co.
707 Army Street
San Francisco, California 94124

Litho-Kem-Ko
46 Harriet Place
Lynbrook, New York 11563
(Lacquer C, Triple Ink)

Philips & Jacobs, Inc.
622 Race Street
Philadelphia, Pennsylvania 19106

Harold M. Pitman
515 Secaucus Road
Secaucus, New Jersey
(Gum Arabic)

Seibold Ink Co.
150 Varick Street
New York, New York 10013

The Steward Co.
1122 South Alvarado Street
Los Angeles, California 90006

Van Water & Rogers, Inc.
3745 Bayshore Boulevard
Brisbane, California 94005

PAPER SUPPLIERS

Andrews/Nelson/Whitehead
7 Laight Street
New York, New York 10013
*(Reeves, Arches, Barcham Green,
Inomachi, German Etching, Italian Etching)*

Buckley-Dunton-Linde & Lathrop
295 Madison Avenue
New York, New York 10017
*(index paper, newsprint, blotters, fine
printing stock)*

New York Central Supply
62 Third Avenue
New York, New York 10003

Zellerbach Paper Co.
234 South Spruce Street
South San Francisco, California 94118
*(West Coast distributors for
Andrews/Nelson/Whitehead)*

INK SUPPLY HOUSES

Borden Chemical Corp.
Ink Division—"Cilco Inks"
1100 Vail Avenue
Montebello, California 90640

California Ink Co.
501 15th Street
San Francisco, California 94103

F. Charbonnel
13 Quai Montebello
Paris, Veme, France

General Printing Ink Co.
Division of the Sun Chemical Corp.
750 3rd Avenue
New York, New York 10017

Graphic Chemical & Ink Co.
P.O. Box 27
Villa Park, Illinois 60181

Handschy Chemical Co.
2525 North Elston Avenue
Chicago, Illinois 60647

528 North Fulton Street
Indianapolis, Indiana 46202

International Printing Ink Co.
Division of International Chemical Corp.
67 West 44th Street
New York, New York 10036

Martin Marietta Corp.
810 East 61st Street
Los Angeles, California 90001

Seibold Inks
150 Varick Street
New York, New York 10013

Sinclair & Valentine Inks
Secaucus Road Extension
Secaucus, New Jersey 07094

F. Charbonnel
13, Quai Montebello and Rue de l'Hotel Colbert
Paris 52, France

L. Cornelissen & Son
22 Great Queen Street
London W.C. 2, England
(transfer paper)

Kast-Ehinger GmbH Printing Inks
Stuttgart-Feuerbach, Germany

INDEX

Boldface numbers refer to illustrations.

09 246

128